ART
ANSWERS

Acrylic PAINTING

EXPERT ANSWERS
TO THE QUESTIONS
EVERY ARTIST ASKS

CONSULTANT EDITOR: JENNIFER KING

Search Press

Copyright © 2012 Quantum Publishing

ISBN 978-1-84448-881-0

QUMAAAC

Publisher: Sarah Bloxham
Managing Editor: Jennifer Eiss
Consultant Editor: Jennifer King
Editor: Julie Brooke
Project Editor: Samantha Warrington
Assistant Editor: Jo Morley
Design: Jeremy Tilston
Production Manager: Rohana Yusof

Printed in China by
Midas Printing International Ltd.

The material in this book has previously appeared in: *Acrylic School* by Hazel Harrison,
Painting with Acrylics by Jenny Rodwell, *Introduction to Painting with Acrylics*
by Alfred Daniels, *The Acrylics & Gouache Artist's Handbook*.

Acrylic PAINTING

EXPERT ANSWERS
TO THE QUESTIONS
EVERY ARTIST ASKS

Pimlott Holm
1990 OPPI

Contents

Introduction

BY JENNIFER KING

Whether you're a consummate painter in some other medium or a complete novice in fine art painting, you are going to enjoy getting to know the medium of acrylics. Just look at the variety of paintings shown across these pages and you will start to understand why. Acrylics allow you to achieve almost anything you can imagine.

Some artists prefer acrylics for practical reasons. These paints are non-toxic and nearly odourless and cleaning up after an acrylic painting session just doesn't get any easier. Other artists prefer the

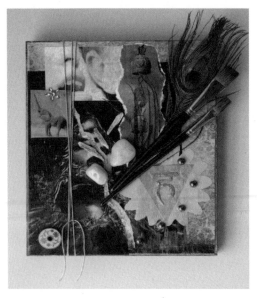

Left: Finding my Voice, *Jennifer King*. Over the last few years, I've devoted a lot of time to discovering who I am and examining the many roles that I play. With the help of many others, I now feel more free to be myself than I ever have before. That's why the image of the Mardi Gras mask in the background is upside down and torn into two. It represents my breakthrough to a place where I have found my voice and can express my true self. Part of this expression, of course, takes the form of my artwork. I hope that you, too, can discover the joy of self-expression through art.

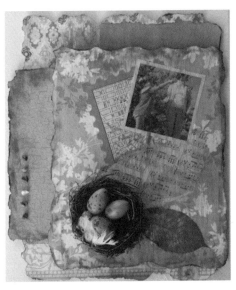

Left: Nest, *Jennifer King*. After more than 15 years as a plein-air landscape painter, I suddenly found myself called to start making three-dimensional assemblages last year. It is a radically different process! Rather than going out and finding a great composition in nature, I now get to build my compositions from scratch. I so enjoy combining images, papers and embellishments and then adding painted passages with acrylic paints. This piece, Nest, is very personal, recalling the happiness of my childhood and my present-day gratitude for my family.

medium because of the quick drying time, which lets them keep going when their creative energy is in high gear. And still others enjoy acrylics because the ability to use the paint in a complete range of applications from transparent to opaque means you can work in virtually any style you prefer.

As for me, a mixed-media artist, I love the fact that I can create an unlimited number of textures and surface treatments and combine those with other media as well.

This book is designed to accelerate your learning process by answering all of your most basic questions about acrylics, from the medium itself to the tools and techniques you can use. Along the way you will find dozens of helpful quick demonstrations, valuable

tips on painting specific subjects and, as I mentioned before, a wealth of inspiring acrylic paintings from a host of talented artists.

Of course, learning to work with acrylics does take some practice. I recommend getting to know acrylics the same way you'd get to know a new friend – spend some time with the medium, pay attention, be gentle, play together, laugh a lot. Experiment without expectations and have fun with the 'happy accidents' that occur along the way. You will soon discover why more and more artists turn to this fantastic medium every day.

Jennifer King

CHAPTER

1

INTRODUCING ACRYLICS

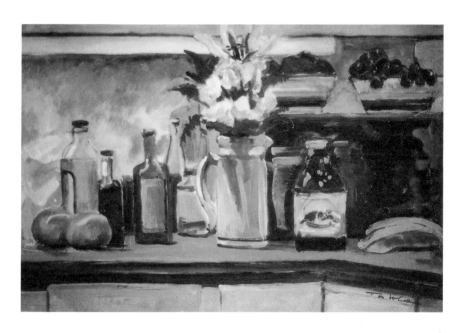

I've never tried acrylics. Could you tell me why I should try this medium?

Yes! For those who are new to acrylic painting there could be no better medium. You can do virtually anything with acrylic paints, which is why they have always been favoured by artists who like to experiment.

Acrylic is a relatively new paint for artists – the first for nearly 300 years.

During that time, painters and designers have used mainly oil, watercolour and tempera. In acrylic, we have a modern paint of enormous value to both artists and designers, whatever fields they are in – painting, illustration, graphic design, textiles, jewellery, mural and interior design, even sculpture.

What are some of the advantages of using acrylics?

The qualities of acrylic are exceptional. It is certainly more versatile than most other paints. For one thing, it can simulate almost exactly what the other paints can do, in many instances more efficiently. It is clean to handle and has only a slight, pleasant aroma. Neither cumbersome equipment nor special chemical knowledge are required to make it function satisfactorily. This alone makes it ideal for those who find oil paint somewhat messy, its smell unpleasant, its use arduous and something of a performance.

But acrylics' capacity for diversity is the main reason for their popularity. You can change their thick creamy tube consistency by adding water *(see page 87)*, or thicken it for oil-painterly effects with a special medium *(see pages 58–66)*.

You can combine different paint consistencies in the same painting, using thin, transparent glazes *(see pages 114–116)* over thick or medium-thick applications and vice-versa. You can use different paint surfaces *(see pages 72–83)* or different grounds.

Acrylic is especially suitable for textured effects *(see pages 118–132)*, which can be produced by painting over a pretextured ground or by mixing paint with substances, such as sand, or one of the mediums made for this purpose.

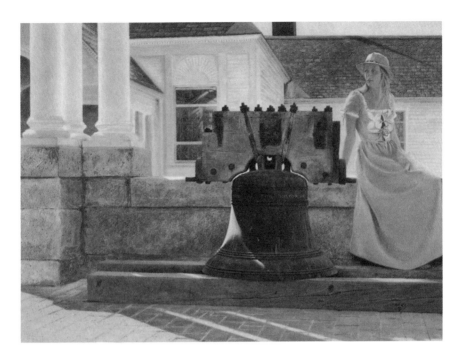

Above: Jennifer and the Bell, *Neil Drevitson. Acrylics can be manipulated so that they mimic traditional paints. Before the introduction of oil paints, tempera (pigment mixed with egg yolk) was the standard painting medium. Tempera paintings are characterised by luminosity of colour, fine detail and a smooth surface, with almost no visible brushmarks – effects that acrylic can imitate successfully. To give the painting above an authentic tempera quality, the artist worked on a smooth-surfaced primed panel and mixed his acrylics with egg yolk to increase translucency and impart a subtle sheen to the surface.*

ARTIST'S TIP

If you want to try your hand at acrylics before investing in a lot of materials, here's a list of essential supplies you will need: small tubes of artists' grade acrylics in a warm yellow (Cadmium Yellow Medium), a cool yellow (Hansa Yellow Light), a warm red (Cadmium Red Medium), a cool red (Pyrrole Red or Crimson), just a single blue (Ultramarine) and White. A large plastic palette, two or three medium-sized synthetic acrylic brushes and a couple of inexpensive canvas panels will round off your starter kit.

Is acrylic paint durable? Will my acrylic works of art stand the test of time?

Yes. Acrylics are very durable. Paintings in acrylic do not crack, fade, or discolour with age or exposure to sunlight. Used on paper, acrylics are less prone to damage than other paints, because once dry they form a tough skin.

Do acrylics only mimic other paints, or do they offer something different?

One of the reasons why acrylics are so popular is that they are adaptable and can be made to look like almost any other medium.

Because of their versatility, acrylics have gained a reputation as an imitative medium. It is true that a painting in acrylics can look very much like one in oils. Oil painters sometimes use acrylics as a substitute when working outdoors because their short drying time makes them more convenient. Acrylics can also mimic the effects of watercolour or gouache (opaque watercolour). But there is little point in trying to make one medium behave like another unless you do so for a specific reason. Acrylics have their own characteristics, and you will enjoy using them more if you learn to understand and exploit these in an individual way. Sympathy with the chosen medium is one of the factors that marks a successful painting – and this book aims to help you achieve it.

If you are not sure what methods to adopt for your first attempts, begin by looking at the pictures shown and techniques explained throughout this book *(see chapter seven, page 104)*. If you respond more to some than others, take them as a starting point for developing your own approach. To a large extent, painting is learned by example and the work of other painters can give you more ideas than weeks spent struggling on your own.

ARTIST'S TIP

As durable as acrylic paintings are, it is still important to treat them as gently as you would any other artwork. Do not hang acrylic paintings in direct sunlight and keep them out of damp places and away from temperature extremes.

Although acrylics can achieve similar effects to oils and watercolours, they do not behave in the same way. The following comparisons will give you an idea of how to create watercolour and oil effects with acrylic.

WATERCOLOUR

In watercolour work, depth of colour is built up in successive layers. The same method can be used for acrylic. Because the paint is nonsoluble when dry, there is no danger of new layers lifting or muddying those below, which is a risk in watercolour work.

Watercolour remains water-soluble even after drying, allowing colours to be lifted off the surface with a damp brush or sponge. You cannot do this with acrylics, which are immovable when dry.

Applying one or more wet colours over another, called wet-into-wet, is a commonly used watercolour technique. You can do this in acrylics, too, provided you work quickly and dampen the paper before painting (*see page 107*).

OIL PAINT

Scumbling (*see page 112*) is a technique originally used in oil painting. It is a slow process because each layer of colour must dry before another is added. With acrylics you need wait only a few minutes before adding a new colour.

Glazing (*see page 114*) is another technique originally used by oil painters. It, too, is slow to use because each layer must dry before another is added. The fast drying time of acrylic makes it quick and easy.

Oil paint takes time to dry, so it is easy to blend colours wet-into-wet. With acrylics you need to add retarding medium to the paint to slow the drying process and paint thickly (*see page 63*).

I've heard that acrylics dry quickly and I'm not sure I'd like that. What's your opinion?

In my opinion, one of the advantages of acrylic is its speed of working. It dries rapidly, in minutes if need be and permanently. Alternatively, drying can be prolonged to suit individual working requirements by adding a retarding medium (*see page 63*). Acrylic dries throughout so thoroughly, it can be varnished immediately with either a matte (eggshell) or glossy finish.

I've noticed that many artists use acrylics in their mixed-media pieces. Why is that?

Acrylic is a multipurpose paint; it can be used as a paste as well as a liquid, enabling a variety of surface changes to be explored. From the perfectly flat, or evenly gradated kind, to the highly modelled, textured surface that has sand, glass, wool fibre and tissue paper added to it (*see page 142*). For among its many attributes, the acrylic medium is also a powerful glue. In addition, acrylics are compatible with a wide range of other painting and drawing media, including watercolours, pastels, inks, charcoal and more (*see chapter eight, page 140*).

Acrylic colours seem very intense to me. Can I use them if I want a natural look?

Acrylic paint will especially suit those who delight in bold, bright, clear colours. Conversely, it can be reduced to subtle tones and carefully gradated tints by mixing the pure colours straight out of the tube with white, black, or other colours. As you are mixing your colours, just remember that acrylics tend to dry slightly darker than how they appear on the palette when wet.

Right: *A detail from* Benches, *Tom Phillips. This painting is based on a series of postcards. The artist has used a number of techniques (e.g. stippling and hatching) and a wide range of colours.*

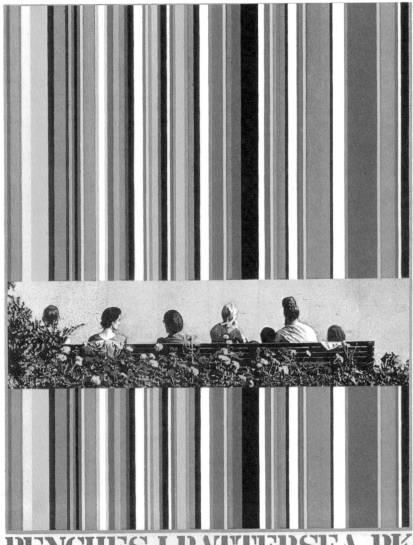

Do you have any advice on learning to use acrylics?

Yes, I do. Acrylic is uncomplicated to use, but it is important to learn how it behaves. Practice and experimentation will teach you how to exploit the qualities of the paint *(see chapter three, page 34).*

Experience with other mediums is not necessary; beginners are at no disadvantage to the more experienced painter in understanding acrylics and the beginner may be less prejudiced and more adventurous than the painter skilled in other mediums.

If you begin with a spirit of enquiry, you will soon grasp the potential of this exciting medium. Keep an open mind and persevere and the results you will achieve will be rewarding.

Do I need a special place or studio when using acrylics?

No, acrylics are suitable for working indoors and out. For those lucky enough to have a studio or a room which can be set aside especially for painting there is no problem. Otherwise, space must be found elsewhere in the home.

If you anticipate a picture taking a few days to finish, you need to work in a place where it will not be necessary to dismantle your easel or subject every evening. Nor do you want to be painting in a place where a constant stream of people can distract you.

Wherever you work, it is a good idea to protect surrounding floors and furniture from spills and splashes of paint. Because acrylic is water-based it is easy to wipe up when wet, but if you allow it to dry you will discover exactly how permanent the colour is. So be prepared and always have a damp cloth close at hand in case of such accidents.

Above: *A room or space where you can paint without distractions is a great help.*

So I can use acrylics for plein-air painting, too?

Yes, acrylics are great for painting outdoors. You would need all of the same equipment you would need for outdoor painting in any other medium.

The big advantage of plein-air painting with acrylics is that your painting will be nearly dry when you are ready to transport it back home. Less mess!

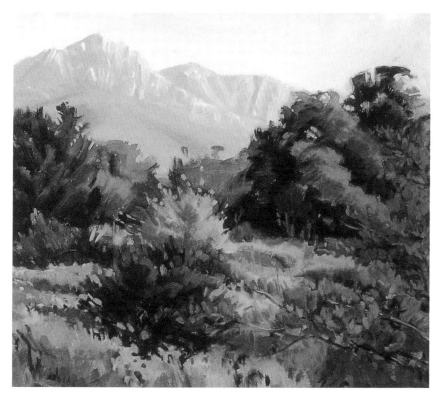

Above: Early Spring on the Porter Trail, *Marcia Burtt. For this nature study done direct from the subject, paint was used at tube consistency, applied with bristle brushes on fine-grain canvas. As she worked, the artist made continual adjustments and rearrangements and built the stronger tones and colours gradually.*

2

UNDERSTANDING THE MEDIUM

I've noticed that acrylic paints vary broadly in price. How do I know what to buy?

The ever-increasing popularity of acrylics has multiplied the variety of paints on the market and the same manufacturers sometimes produce several lines. This can be confusing for the beginner.

The only difference between 'artist's' and 'student's' quality paints is that the latter are made from less expensive pigments. In most cases, however, they are vivid and durable. They also cost considerably less than artist's quality paints, so they are a good choice for first attempts. They are seldom denoted as student's quality on the tubes, but the more expensive paints are always marked artist's quality or artist's acrylics. If in doubt, ask for the manufacturer's information sheet.

Left: *Flow-formula artist's paints, produced by this manufacturer in uniform-sized tubes and a wide range of colours.*

Is there any difference between the acrylic paints that come in tubes and the paint that comes in jars or pots?

Several manufacturers produce the same paints in both tubes and plastic pots of various sizes. These are useful for large-scale and indoor work, but they are less portable than tubes for outdoor sketching. Choose pots or jars that have a nozzle under the cap, as shown in the photograph. This allows you to squeeze just the right amount of the paint out. If you have to dip your brush into a pot or jar of paint and the brush is not perfectly clean, you will pollute the colour.

Left: *Consider how much of a particular colour you will need and when and where you will use it, before deciding whether to buy it in a tube or jar.*

What's the difference between 'heavy body' or 'full-bodied' paints, and 'flow formula' or 'soft body' paints?

Some acrylics are relatively thick and buttery, described as full-bodied, while others are runnier, known as flow-formula. Again these characteristics are not always indicated on the tube, but some brands contain the word 'flow' in their name. Artist's quality acrylics are made in both consistencies, but most of the student's quality paints are the flow type.

Above: *A range of high-quality full-bodied artist's paints, suitable for both thick and thin applications and made in a wide range of colours. Most manufacturers produce a range of paint formulas.*

Is there any advantage in buying smaller tubes or larger tubes?

Larger tubes can be a great way to save money on those colours you use most often. Some paint manufacturers produce two sizes of tubed colour, usually 20ml (0.67fl oz) and 74ml (2½fl oz). You can economise by buying smaller tubes of any colours that you use infrequently. White, which is used up quickly if you are using your paints thickly, can sometimes be obtained in especially large tubes 125ml (4.2fl oz).

Above: *Buy colours you use often, or in quantity, in large tubes. Small tubes are best for colours you use rarely or wish to experiment with.*

In a nutshell, how is acrylic paint made?

Acrylic paint is made by mixing powdered pigment with acrylic adhesive. The adhesive looks milky when wet but becomes transparent when dry, revealing the true colour of the pigment. In factories where the paint is made, before the enhancing colour is added, you can see the enormous vats of this raw, jellylike substance being wheeled to and from the mills and mixing machines that eventually produce the finished paint.

All the ingredients are carefully weighed and tested before use. It is this painstaking precision and control during manufacturing that enables thousands of tubes of paint of almost identical colour, consistency and quality to be turned out at any time.

How acrylic paint is made

1. The first constituent is the powdered pigment.

2. The pigment is mixed with acrylic adhesive.

3. The paint is then milled between steel rollers.

4. The paint is inspected and put into tubes.

Are these the same pigments used in other types of paints?

Yes, they are. The major difference between one paint and another is not the colour but something much more fundamental: the binder. This largely decides the character and behaviour of the paint. Binders also play a large part in permanence and drying qualities, brilliance and speed of working. They also determine what kinds of diluents (also known as solvents) and varnishes may be used with them. For instance, water is the diluent for watercolours and gouache and turpentine for oil, because of the binders used.

Left: *Metal scoops are used for pigment powders, each colour being kept strictly separate. The scoops here are reserved for blue cobalt.*

Have these pigments always been used for artists' paint?

For the most part, yes. To understand pigments and pigment colours used today, it is helpful to take a brief look at the history of paint pigments.

Pigments are the colouring materials of paint and are usually made in the form of powders. From the earliest times, pigments had to be bright and clear and able to withstand prolonged exposure to light. Certain colours were apt to fade and did not produce the subtle tints and shades we would admire today; they were more likely to produce a dead or muddy effect.

Throughout history, bright colour was preferred for both practical and aesthetic reasons, having close associations with joy, celebration, pleasure and delight. To express these emotions, bright, rich hues were in demand and the search for pigments that possessed these qualities has been constant over the centuries.

By the Middle Ages the range of colours was quite extensive and put to complicated use on walls, illuminations, panels, in books and on woodwork. An all-purpose paint such as acrylic would have suited them admirably.

After the Renaissance, pigments reached a peak of brightness and variety. Thereafter a more expressive and realistic style emerged and the medium more suited to this was oil paint. Realistic paintings moved away from bright colours to rich, somber hues, which brought a new range of pigments into being. An interest in brighter colour returned again in the 19th century due, in part, to Constable and Turner and later, the designs of William Morris and the Impressionists.

Delight in bright colour today means there is a wide range of pigments, and the list of those available is long. The names of pigments often echo those of towns and countries: burnt Sienna, Venetian red, Naples yellow, Prussian blue, Chinese vermilion; or recall the materials they are derived from: cobalt blue, rose madder, emerald green, ivory black, sap green, geranium lake and so on. Though interesting sounding, the names give little indication of the quality or behaviour of colours and some shades are sold under two or three different names.

I have heard some colours referred to as 'organic,' and others as 'inorganic' or 'synthetic'. What does that mean?

These terms also relate to the history of pigments used in art. The raw materials used to provide the pigments are customarily classified as inorganic or organic. Inorganic materials are those of purely mineral origin, such as the natural earths: ochres, raw umber – which can be calcined like burnt umber and burnt Sienna – and artificially prepared colours such as cadmium yellow and zinc oxide, the basis of the famous 'Chinese white' which was introduced in 1837 by Winsor & Newton.

Organic pigments include animal and vegetable substances, as well as complex synthetic substances. Vegetable sources furnished colour like gamboge, indigo (now not available) and madder. Animal sources produced cochineal which was made into carmine and Indian yellow was an incredible colour made in India from the urine of cows fed on mango leaves. It has now been replaced by synthetically made colours. Other artificially prepared organic colours include alizarin, or anilines (now largely discontinued for artists' colours, but occasionally used as constituents of household paints and printers' inks).

Many of these organic colours are no longer produced and have been replaced by newer and more durable colours that have been developed successfully over the years. Notable among these is the plithalocyanine range, the first of which was a very intense blue, known under the trade name of Phthalo blue. This was a suitable replacement for the less reliable Prussian blues, whose colour effects and pigment properties it closely resembles.

The range has now increased to include yellows, reds and greens and a splendid violet, all of them available in oil, watercolour and acrylic. These colours are classed as organic and are derived by a chemical process from an organic dyestuff. They are very intense with a high degree of durability and, like acrylic paint itself, are a modern and flexible addition to the artist's means of expression.

ARTIST'S TIP

Most acrylic manufacturers also offer a couple of metallic tube colours, such as silver, copper, or bronze. While they may not be appropriate for traditional art styles, they certainly add pizzazz to collage and mixed-media pieces.

What does the word 'binder' mean?

When you look at pigments in their powdered form *(see page 24)*, they are fresh and bright with a beauty all their own. When mixed with a small quantity of plain water, a paste is formed that can be used for painting. When the water dries, the bloom returns, but so does the powder. In other words, the paste reverts to its former state. What is needed is something to bind the coloured grains together to make them adhere even when dried. For this purpose, some kind of glue or binder must be added to the powder before it actually becomes paint. For acrylic paint, that binder is a polymer resin.

Above: *Acrylic resin, a binding agent, is added to the pigment base. When the paint dries the binder will 'hold' the paint in place on the painted surface and protect it.*

What makes acrylic paints so durable? Is it the acrylic binder?

That's part of it. Acrylic enjoys a reputation as the most hard-wearing and weather resistant of all artists' paints – a reputation that depends on certain essential ingredients. The mixture of resin and pigment used includes a special preservative to prevent deterioration; an antifreeze to stop tubes from freezing up in cold weather; a thickening material to give the acrylic a consistency similar to that of oil paint; and, finally, a wetting agent to stabilise the paint and disperse the pigment evenly in the resin.

Above: *The paint is checked before being packaged in pots and tubes.*

Above: *Acrylic paint is mixed thoroughly in large quantities to obtain the consistent colour and quality in every batch that is necessary for artists.*

Many colours look quite different when they are wet compared with after they have dried. Why is that?

That has to do with the way the paint is manufactured and the polymer resin emulsion that is used as the binder. To obtain the extremely fine texture of the finished paint, ingredients are ground thoroughly in special mills.

In contrast, oil paint is traditionally ground between heavy granite rollers. Suitable 'hi-tech' steel that is used in the manufacturing stages disappears as the water evaporates, leaving the plastic coating as clear as any truly transparent plastic, such as Lucite.

Consequently, an almost ideal paint is made. This coating of each tiny particle of pigment with a practically indestructible layer of transparent plastic gives the artist a pure colour that will not rot, discolour, or crack and has few of the faults and drawbacks found in more traditional artists' colours.

How can I learn to adapt to this colour change after drying?

It may seem like a source of frustration at first, but do not worry. With experience, you will learn to allow for this by mixing colours just a little lighter than you need. If you want to match a colour exactly, perhaps to correct an error, paint a swatch on a piece of paper, hold it up against the colour to be matched and adjust it as necessary until you are satisfied with the result.

Above: *Paint has a sheen while still wet.*

Above: *It dries matte and the colour darkens.*

When were acrylic paints invented?

An American firm, Rohm and Haas, first started to experiment with synthetic resin in the 1920s. The following decade saw it being used for small items such as false teeth and the heels of shoes.

These early acrylics, or polymers, were eventually developed as a base for house paints. These were found in pastel colours only because the resin emulsions used at that time could not absorb much pigment without solidifying. This form of paint was therefore of little use to the artist. Yet it was becoming more and more necessary to find a resin that would provide a suitable base for acrylic colour for painters, one that would not crack or discolour and was, above all, resistant to the weather and atmospheric extremes.

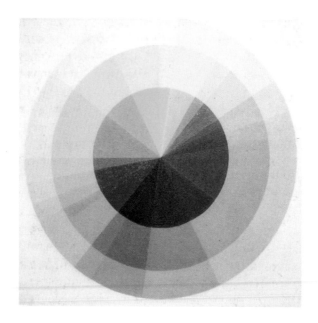

Above: Interpretation of Seurat's Colour Wheel, *Bridget Riley. The painting is one of many commissioned by Rowney to test the quality of its acrylic range. Strong colours at the centre of the wheel are extended to show the whole range of subtle pastel shades.*

When did artists first start using acrylics for creating artwork?

As far back as the 1920s a group of mural painters in Latin America, mainly Mexico, planned large murals for public buildings. These artists, notably David Alfaro Siqueiros (1896–1974), José Orozco (1883–1949) and Diego Rivera (1886–1957), were acutely aware of the inability of oil paints and frescos to stand up to outdoor weather conditions and were eager to help any research that would solve this problem. They realised that the solution lay in synthetic resin, which was already being used in industry with success. By the mid-1930s Siqueiros's workshop in New York was experimenting with new paint formulas. Artists and scientists worked together to further mutual interests – and so acrylic painting was born.

It was not, however, until World War II that manufacturers of artists' materials began to focus seriously on making a paint based on the new resin. The first company to make a form of acrylic paint with enough saturated colour to be useful in the design field was the American firm 'Permanent Pigments'. Its product was called Liquitex, a resin emulsion of the same consistency as poster colour. This was welcomed by designers and its reputation quickly spread to the fine arts.

The initial problems of hardening that occurred when the resin was mixed with too much pigment did not vanish overnight. In these early days, many companies ran into great difficulties when they first started to produce new paint and the slightest overloading of a pigment would quickly cause the paint to become unusable.

By the 1950s, acrylic paints were on sale in the United States and were warmly welcomed by many young painters who were eager to experiment with this new medium, notably the many abstract and Pop artists working at that time. By the 1960s, the new colours were also available and widely used in Europe.

ARTIST'S TIP

When you're painting with acrylics, always keep two containers of water near your palette. Use one as your 'dirty' bucket for rinsing paint out of brushes and the other as your 'clean' bucket for dampening your brush before you mix up a fresh colour. Keep some paper or cloth towels nearby as well and train yourself to always follow this routine: swish out your dirty brush, blot the excess dirty water on the towel and then dip your relatively clean brush in the fresh water before returning to the palette. This will help keep your paint mixes fresh and bright.

Are there any really famous artists who have used acrylics as their medium?

By the 1950s acrylic paints were on sale in the United States and were welcomed by many young painters who were anxious to experiment with it, notably abstract and Pop artists. By the 1960s the new colours were available in Europe.

When Jackson Pollock said in 1951 'My painting is direct…The method of painting is the general growth out of the need…I cannot control the flow of paint…' he was putting into words the ideas of many artists in the Abstract Expressionist movement, ideas which were made more practicable with the advent of acrylic. It enabled them to use colour freely and quickly.

One of the great advantages of acrylics was that it could be used directly on raw canvas. With oils it had always been necessary to size and prime the canvas before starting work. This meant that the weave of the canvas fabric could be used as an integral part of the picture.

The American painter Morris Louis was among the first to take advantage of this. As early as 1953 he was experimenting with acrylics to achieve the transparent, overlapping shapes characteristic of his large abstract paintings. By using thin, transparent washes he was able to 'stain' the raw canvas, without losing either the brilliance or transparency of the colours.

The advent of acrylics was an important factor not only in the development of Abstract Expressionism but also of American abstract painting as a whole. It was also a crucial element in the techniques of artists of other styles. Mark Rothko, Kenneth Noland and Robert Motherwell all used acrylic colour, although in very different ways.

Outside the United States, in the late 1960s, artists were trying out for themselves what many American painters were already familiar with. The British artist Bridget Riley, for example, a major exponent of Op, or 'optical' art began using acrylics at around this time. On both sides of the Atlantic, 'Pop' art, based on mass-media images, advertising slogans and other artefacts of the 1960s 'pop' culture, was produced by artists as diverse in style and choice of subject matter as Peter Blake and Eduardo Paolozzi in Britain and Roy Lichtenstein and Andy Warhol in America. Acrylic colours, synthetically made and plastic-based, were very much in the spirit of the Pop movement. The flat, instant colour was adopted by most of the painters and was used in Lichtensteins's comic strips and Warhol's portraits, among many others.

Many figurative painters moved away from oils at that time and began to

work in acrylics. Oil paint may have been easier to manipulate – colours could be blended and 'chiaroscuro' effects could be obtained quite easily with the slow-drying oils – but acrylics had other advantages.

David Hockney found that being able to divide the picture into large, geometric areas of flat colour at the first stage of a painting gave him a new freedom. Because the initial colour dried instantly, the detail, texture and rendering could be applied systematically and almost immediately.

It is interesting to note that Hockney made the transition from oil to acrylic when he went to California in 1964. The scenery on the west coast of America was less cosy and compact than in Europe and the cloudless skies, vivid light and intense heat encouraged him to look for new ways of capturing these characteristics. His search led him to Liquitex and its extensive range of bright, new acrylic colours.

An ultra-realistic approach to figurative painting was also prevalent in the 1960s. This was often referred to as 'Photorealism' because the technical competence of many of the artists made the paintings look like photographs. Some of this work was done in the traditional manner, with brushes, but often the artists used an airbrush to spray colour on to the support in fine, graded layers.

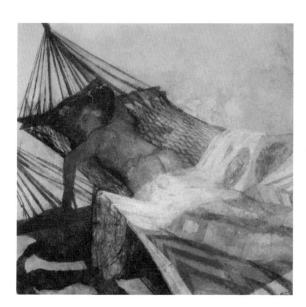

Left: Girl Lying in a Hammock, *Leonard Rosoman. In this Rowney 'test painting' the artist used layers of brilliant coloured glazes to build the image. The painting shows the acrylic technique at its best.*

3

GETTING STARTED WITH ESSENTIAL MATERIALS

Do I need a lot of equipment and materials to get started with acrylics?

No, perhaps one of the best things about acrylics is that you do not need a lot of equipment to get started. The equipment for painting with acrylics is not complicated. All you actually need are a few tubes of paint, a brush, something to paint on and a jar of water. You will probably, however, soon find this selection limited and will want to extend your choice of materials as you become more proficient in the medium.

This next section covers the tools and materials available for acrylic painting, but there is no need to rush out and buy every item before starting work. It is far better to begin with a few essential pieces of equipment and a limited range of colours, adding more to these gradually as you gain experience and increase confidence, than to make a large and often unnecessary investment during the early stages.

What colours do you recommend I start with?

A starter palette must contain two of each of the primary colours: red, yellow and blue. As you can see from the colour swatches opposite, there are different versions of each colour and you need both to make successful secondary colours: greens, oranges and purples.

Secondary colours are a mixture of two primaries, so you could manage with the six basic colours alone, plus white, but this would mean spending as much time mixing colours as painting. Also, some of the ready made secondary colours, notably the purples, are brighter and purer than those you can mix yourself and so a small selection of these is recommended.

A good range of browns, known as tertiary colours, can be mixed from the primary and secondary colours in your palette, but again, it saves time to have one or two ready-made ones on hand.

Tertiaries and secondaries are useful both on their own and for modifying other colours. For example, a little purple added to a sky blue will deepen it; and a touch of brown mixed into an over-bright green or red will reduce its intensity. The grey included in most starter palettes are formulated especially for toning down colours without making the finished shade appear muddy.

This suggested palette contains thirteen colours, plus white, black and grey, which is more than adequate for most subjects.

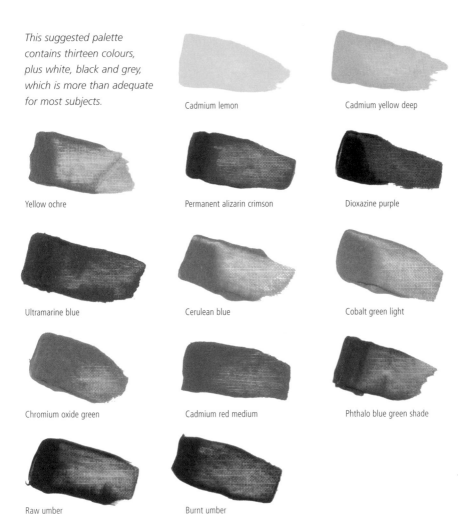

Cadmium lemon

Cadmium yellow deep

Yellow ochre

Permanent alizarin crimson

Dioxazine purple

Ultramarine blue

Cerulean blue

Cobalt green light

Chromium oxide green

Cadmium red medium

Phthalo blue green shade

Raw umber

Burnt umber

Any other tips?

Yes, here is another one: the nozzle of the tube of paint must always be cleaned after use and before replacing the cap. This will prevent air from penetrating the tube and solidifying the contents.

If I'm trying acrylics for the first time, would it be better for me to buy a starter set?

I wouldn't recommend it. Some paint manufacturers sell starter sets, usually consisting of six to eight tubes of colour. Some of these sets lack essential colours, while including colours you can easily mix yourself, so it can be preferable to make your own selection. Alternatively, begin with an introductory set such as these and add to it as you discover what you need.

How do I keep track of all these colours?

I have several tips to help you to do this. Do not set out your colours in a random way, squeezing out whichever one comes to hand. Decide on a sequence of colours and repeat the same order every time you paint. This makes it simpler to find and identify a colour, especially the dark colours, which look similar in undiluted blobs and can easily become jumbled. The order you choose is up to you; different artists have different ways of setting out their colours. On this palette, the two browns are placed first; then yellow ochre, which is more brown than yellow; the two greens; the yellows; the reds; the blues; Davy's grey; and finally black. The white is kept separate to avoid contamination with the colours.

Below: *Once you have decided on a sequence for your colours you will be able to find them instinctively when you are painting.*

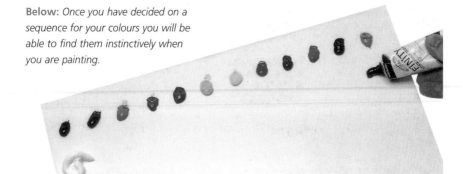

What kind of palette should I use for mixing my acrylics?

Acrylic will not adhere permanently to a non-porous surface, so this is the main requirement for a palette. Do not use the wooden palettes sold for oil painting – you will not be able to remove the paint after use. Some art suppliers carry white plastic palettes for acrylic painting, but you can easily improvise your own mixing surface. For acrylic used relatively thickly, a sheet of glass is ideal, though only for indoor work.

An alternative would be a piece of laminated particle board, such as Formica, or you can use old ceramic or enamel plates. These are easy to clean and will not stain, whereas a laminated board will retain some of the paint dyes.

Acrylics will dry out quickly on any of these homemade palettes, so use a plant spray or other atomiser to spray the colours with water from time to time – before they begin to acquire the skin that indicates drying. To keep the paints workable while you take a break, cover the palette with plastic wrap.

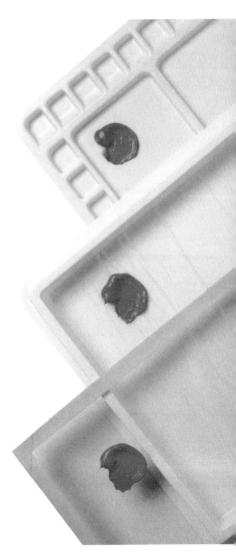

Right: *There are several palette types to choose from. From top to bottom: Plastic palette, stay-wet palette and plate glass, its edges bound with tape for safety.*

Those are a lot of options. Which palette do you recommend?

If you are willing to invest a little more money in setting up your new acrylic studio, I would recommend buying a ready-made plastic palette with compartments. If you like thin paint you may find a palette with separate compartments more satisfactory. These prevent mixed colours from flowing into one another or slopping over the edge while you work.

I've seen something called a 'moisture-retaining palette'. Should I get one?

A moisture-retaining palette, also called a reservoir palette or a stay-wet palette, can be very useful if you find that acrylics' short drying time is a problem for you while you work.

This is a deep tray with a clear plastic lid that holds water to keep the paint moist. The paints are laid out and mixed on a sheet of special paper, with a piece of dampened absorbent paper underneath. Sufficient water seeps up through the paper to keep the paint moist while you work. Replace the plastic lid after a working session and the paint will remain damp for at least a week, avoiding wastage.

The side compartment can be half-filled with water to keep brushes moist, or it can be used as a subsidiary mixing surface.

How should I clean my palette when I'm finished?

Any palette, including a reservoir palette, can be cleaned simply by rinsing it with plain water and then drying it with a soft cloth. If any paint has dried on to the surface, soak it in water to soften the paint before you wash it away.

I have quite a few brushes already. Do I need to buy new brushes to use with acrylics?

No, you can probably use most of what you have. To some extent, your choice of brushes will be dictated by the size of your work and whether you like to apply the paint thickly or thinly. The bristle brushes used by oil painters and the soft brushes made for watercolours are suitable for acrylics, but avoid expensive sable brushes, which could be spoiled by constant immersion in water.

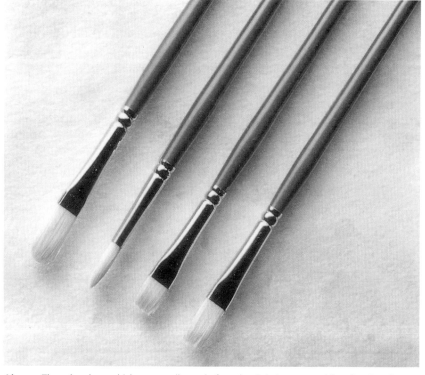

Above: *These brushes, which are usually made from hog's hair, are good for oil-painterly effects. Shown here from left to right: filbert, round, short flat (square-ended)and long flat (a variant on the standard shape but with longer hairs).*

If I am going to buy new brushes, what should I buy?

The major manufacturers produce synthetic brushes designed especially for acrylic painting. These are tougher and springier than the synthetics made for watercolours. They are an ideal choice for beginners, because they are durable, keep their shape well and are suitable for both thin and thick methods.

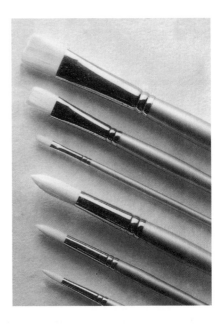

Right: *Even a beginning acrylic painter should have a selection of both flats and rounds – three or four of each – in a variety of sizes, anywhere from size two to twenty. Synthetic bristle brushes are a good choice because they're durable and versatile.*

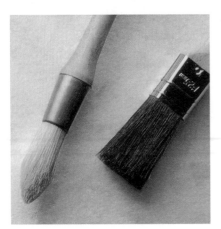

Far left: *A soft-haired mop brush is useful for glazes and watercolour-type applications over large areas. This one is made from goat hair; others are manufactured from squirrel hair.*

Left: *Household brushes are handy for covering large areas quickly and good for laying coloured grounds.*

Is there a specific shape of brush that works best with acrylics?

You can use all brush shapes with acrylics, depending on what you want to achieve. There are three basic brush shapes: square-ended, round and filbert. Two different sizes of the first two, and one middle-sized filbert will make an adequate starter kit.

You can then extend your range later according to your own needs. You may, for example, find a large soft mop brush useful for glazing large areas and one or two bristle brushes for oil-paint effects and for exploiting brushmarks.

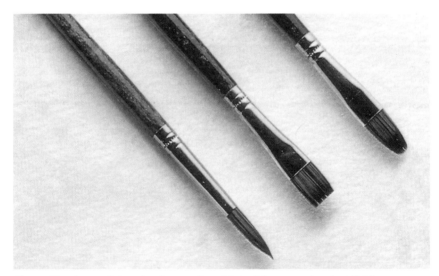

Above: *The shapes of these brushes are, from left to right: a round, a short flat (square-ended) and a filbert. Some manufacturers offer two versions of the flat – a long and a short – while others exclude the filbert shape.*

ARTIST'S TIP

Most beginners gravitate toward small brushes, thinking they'll have better control. But professionals will tell you to always use the biggest brushes you can. Your paintings will look more lively and less fussy.

What do the different brush shapes allow me to do?

You will learn best by experimenting with each shape *(see pages 49 and 88)*, but here's a general list of how they might be used:

Bright Flat ferrule, short-length hairs, usually set in a long handle. Useful for short, controlled strokes and with thick or heavy colour.

Fan Flat ferrule, spread hairs. Natural hair is more suitable for soft blending and synthetic works well for textural effects. Useful for smoothing and blending, special effects and textures.

Filbert Fuller in shape than flats, with slightly rounded ends that make soft, tapered strokes.

Fitch Straight edges and chiselled sides set in a round ferrule. Long handles. Used for applying lots of colour and is effective on textured surfaces.

Flats These have long bristles with square ends. They hold a lot of paint and can be used for bold, sweeping strokes, or on edge for fine lines.

Hake An oriental-style wash brush on a long flat handle. Useful for laying in large areas of water or colour.

Mop A round, full version of the wash brush, made of soft, absorbent natural hair. Useful for laying in large areas of water or colour, for wetting the surface and for absorbing excess media.

Oval wash Wash brushes come in varied shapes. The oval wash has rounded hairs, flat ferrules and produces a soft edge with no point. Useful for laying in large areas of water or colour, for wetting the surface and for absorbing excess media.

Round Round ferrule, round or pointed tip. Available in a wide variety of sizes. Useful for detail, wash, fills and thin to thick lines.

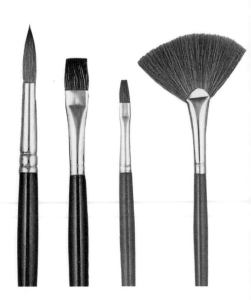

Right: Brush types, from left to right: red sable round, Russian sable bright, red sable bright, red sable fan

Where can I get really big brushes for use on very large canvasses?

Large nylon brushes, such as those sold in hardware and decorators' stores, can be invaluable for applying large areas of colour and when blocking in. They come in all sizes from about 1.25cm (½in) wide to 15cm (6in) and more. They are cheaper than those sold in art stores and the better quality ones are just as good and often easier to use.

Left: Two Trees, *Paul Powis. While some paintings in acrylic look similar to oils or watercolours, the medium used for this painting would be identifiable by anyone familiar with acrylics. The artist exploited the full range and versatility of the medium, combining different consistencies of paint with bold and inventive brushwork. The treatment of the foreground, where colours were layered over one another so that each shows through the next, is especially effective. Broad brushstrokes of paint were mixed with acrylic medium to make it transparent and laid over earlier applications of both transparent and opaque colour.*

What is the proper way to wash my brushes when I'm finished using them?

The most important thing to remember about acrylic paint is that it dries rapidly and it can ruin paintbrushes unless you keep them wet throughout the working process. Do not leave your brushes to stand for long periods in water, because this can bend and splay the bristles.

Rinse your brushes well after each application of paint so that they remain damp, or place them flat in a shallow dish when they are not in use. The reservoir palette shown on page 40 has a compartment designed especially for this purpose.

1. Brushes quickly become clogged with paint, from the tip to the ferrule.

2. Before immersing in water, very gently remove the excess paint with a palette knife.

3. Rinse the brush in warm water. Then clean it by rubbing the bristles and ferrule in the palm of a well-soaped hand.

4. Often the hairs will become splayed. To reshape, dampen the brush and stroke it between finger and thumb.

How should I dry and store my brushes?

The best way to dry your brushes is to stand them up-ended in a jar until dry. You can also store them this way if you use them often, but if you're not planning to use them again for a while, you may want to put them in a fabric brush holder after they are thoroughly dry. This will keep them free of dust and dirt.

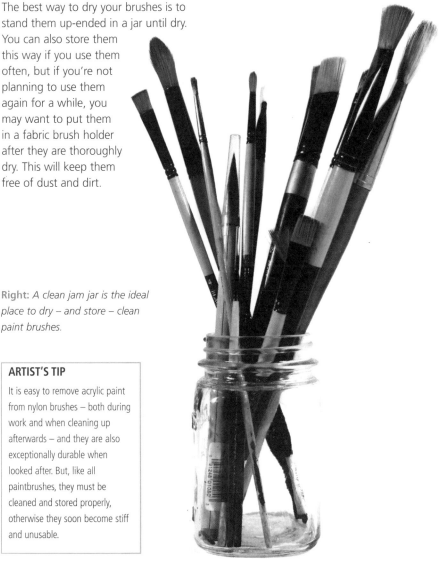

Right: *A clean jam jar is the ideal place to dry – and store – clean paint brushes.*

ARTIST'S TIP

It is easy to remove acrylic paint from nylon brushes – both during work and when cleaning up afterwards – and they are also exceptionally durable when looked after. But, like all paintbrushes, they must be cleaned and stored properly, otherwise they soon become stiff and unusable.

If I forget to wash my brushes and let the paint dry on them, can I rescue them?

You probably can. If brushes are encrusted with dried paint, you can try one of these two methods. Soak them in warm water for a few hours. Warm water will soften the paint and then it may be removed by easing it off carefully, preferably with the fingers. Avoid using any kind of sharp implement, such as a knife to do this part of the job. You may damage the hairs irrevocably if you do. Once the point or edge of a brush is damaged, the brush is virtually useless. Or try a solvent or brush cleaner made for use with acrylics.

Any other tips on caring for brushes?

You can help make your brushes last longer by using them gently. One way of avoiding vigorous handling is to hold the brush lightly so that it almost falls from your hand, rather then gripping it so tightly your hand becomes tense. Let the brush take the strain, which will in turn show in the brushmarks.

This may seem obvious, but for those unused to the behaviour of brushes, tension may easily be the result of unfamiliarity with them.

Brush marking and manipulating exercises and experiments will be of considerable help in overcoming this problem.

Should I experiment with the brushes too?

Oh, yes, definitely. Your brushes are your working tools and the task of visual description becomes easier and more satisfying when you choose the right one for the job. Size is one consideration. There is also a variety of different shapes (see pages 41–44) and you need to become familiar with their possibilities.

Work on a smooth surface, such as acrylic sketching paper or primed board and try out all your brushes to see the kinds of marks they produce. Practise different ways of holding them, making sweeping strokes with the brush held near the end and smaller, tighter ones holding it near the ferrule – this gives

you maximum control and is the grip to use for details, where accuracy is important. If you have both nylon and bristle brushes, you will find nylon best for laying flat colour, while bristles give a more rugged texture.

Large square and medium square brushes. These brushes make brick–like marks.

A filbert brush produces a more rounded stroke, which can be graded to a point by reducing pressure at the end of the stroke. The brush can also be used on its side.

A medium round brush held at the end vertically, with the surface horizontal.

A round–ended brush makes small dabs and dots, or lines that can be varied from thick to thin by increasing or decreasing the pressure.

A small, pointed nylon brush held loosely in the middle.

The smallest pointed nylon brush held tightly at the ferrule.

Paint laid on flat with a large square nylon brush recharged after each stroke.

Medium–size flat bristle brush used with dabbing motion and held near ferrule.

Sweeping strokes made with a bristle filbert held loosely near the end.

Why are these experiments with brushes important?

A good painting, whether a landscape, a still life, a flower painting or a portrait, relies for its success on several important factors. One of these is the way that the paint is applied to the painting surface *(see page 49)*.

Inexperienced artists often fail to give much thought to brushwork, which is hardly surprising since the problems of making a subject look convincing require quite enough effort. But it is important to remember that a picture is more than a representation of the world – it is an object in itself, with its own physical presence. And brushwork is not just the icing on the cake – it is an integral part of the final image.

Apart from creating a lively and attractive picture surface, the way you use your brush can help you to describe objects. If you are painting flowers using thick paint, for instance, you can often represent a leaf or petal with one deft flick of the brush. In a landscape you can allow your brush to follow the direction of a tree trunk or the furrows of a plowed field. Using this technique will also give your painting a sense of movement and dynamism.

Acrylic paints hold the marks of the brush very well, especially if you thicken them with a bulking medium, so it would be a pity to ignore this opportunity in your painting.

Brushwork can play a part in thin acrylic techniques, too. You might use long, linear strokes for hair in a portrait, calligraphic squiggles and broken lines for reflections in a watery landscape and loose blobs for foliage. It is worth experimenting with a variety of brush shapes to find out what kinds of marks each one can make.

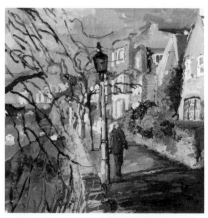

Above: Strand on the Green, *Gary Jeffrey Working on primed paper for this painting, the artist has used thick, juicy paint and his energetic and positive brushwork gives a feeling of excitement and movement to the composition.*

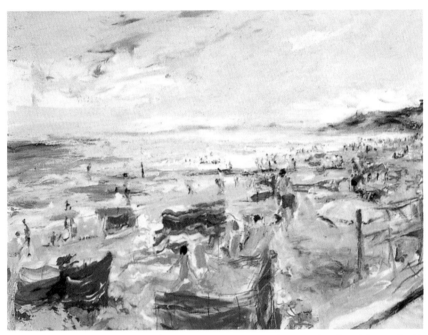

Above: Bournemouth Beach, *Jacquie Turner. Equally lively and exciting brushwork is seen in this delightful painting done on smooth watercolour paper. Here there is a contrast between thick and thin paint, as well as between deft stabs and flicks of the brush and smudged paint – this artist uses her fingers as well as brushes.*

If I have paint left on my palette at the end of the day, can I save it? I hate to waste it.

Yes. If the paint is fresh from the tube or jar and has not been touched, you can try returning it to the original container. Be sure to clean the rim thoroughly before replacing the lid.

Acrylic paint that has been mixed will also last indefinitely, so long as the water in it doesn't evaporate. Therefore, any mixed colour can be stored in a small jar or airtight container with a tightly closing lid. Put a dab of the colour on the lid of the container to help you to identify the colour immediately the next time you need it.

Am I going to need a palette knife?

A palette knife, or even several, is certainly a useful tool to keep with your acrylic painting gear. For mixing and cleaning paint, the palette knife is a vital and necessary part of any paintbox and you can also paint with it. For those who find brushes awkward or difficult to manage, the palette knife will provide the answer. Clean, well-mixed paint can be applied to the support with broad, vigorous strokes. For finer work, specially fashioned knives (known as painting knives) make a variety of delicate marks that are very effective. Of course, for more intricate painting and finish, brushes are the superior tools, but for certain kinds of effects, the painting knife can be extremely successful.

Knives, whether for palette or for painting, consist of a wooden handle and a metal (or plastic) blade. They may be straight or angular. The straight are continuous, from the wooden handle to the blade, which must be of either stainless steel or plastic. The angular have a bend that enables them to be manipulated more easily for both mixing, painting and cleaning.

Broad-faced knives, like putty knives and printers' mixing knives, tend to be too large and clumsy for acrylic mixing and painting. The most suitable is an angular knife that is not too small or too flexible, that will clean, mix and apply paint equally well. The aim should be to use both palette knife and brush, switching from one to the other as the situation demands.

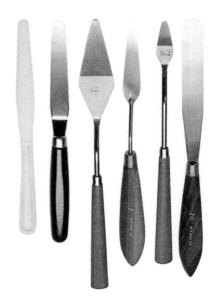

Above: *Both painting knives and palette knives have flexible blades which make it easy to apply and manipulate the paint.*

How do I know when to mix my paints with a brush and when to use a palette knife?

This depends upon the way you work. For thin or medium applications, a brush is the usual mixing implement, but for thick impasto or large-scale work, a palette knife is sometimes used. In either case, make sure the colours are thoroughly mixed or you will have streaks when the paint is applied.

Left: *Mixing with a brush. This is the usual way to mix acrylic paint colours.*

Left: *Mixing with a knife. This method is ideal for thick impasto or a mural.*

Are there any other tools I need for applying acrylic paint?

As you learn more techniques, you will discover ways to use other tools, such as sponges and rollers, but a selection of brushes and a palette knife or two are really all you need to get started with acrylic painting.

Will acrylics wash out of my clothes?

Not really. Dried acrylic is virtually impossible to remove from fabrics; it is therefore best to wear old clothes or an overall when painting.

If you consider yourself to be a particularly flamboyant painter it might be advisable to wear old shoes and a hat as well!

What type of easel should I use when painting with acrylics?

Unless you are using thin washes of acrylic, any one of the many available easels could suit your purpose. The final choice will depend on what size you normally work on, the type of support you paint on, whether you prefer sitting down or standing up and, of course, whether or not you need an easel which is portable.

If you use a lot of water with the paint, applying it in washes of thin, runny colour, then an upright easel is not for you as the colour will run as you paint. An adjustable drawing board which tilts to any convenient angle could be the answer. Or, if you prefer something that can be folded up and carried around, an easel which adjusts to the horizontal position and which will prevent the paint from running off would be more suitable. (See examples opposite.)

ARTIST'S TIP

As you will soon discover, acrylic paints do dry quickly, even while they're still on your palette. If you'd prefer to use any type of palette other than a stay-wet palette, you can combat this problem by keeping a spray bottle of water nearby, preferably one that sprays a light mist rather than a heavy blast of water. Then occasionally mist your palette with water to keep the paints workable. Another smart move is to put out relatively small amounts of each colour and refill as needed.

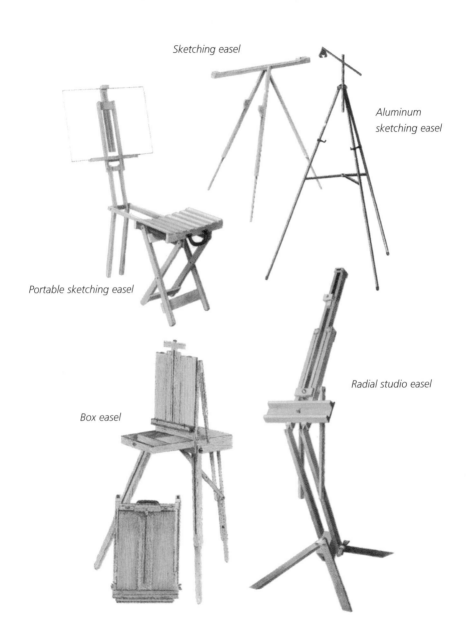

Sketching easel

Aluminum
sketching easel

Portable sketching easel

Box easel

Radial studio easel

CHAPTER

4

DISCOVERING
ADDITIONAL
MATERIALS

What does the word 'medium' mean when I'm working with acrylics?

The word 'medium' has two meanings for the artist. The broader sense of the word refers to the material used for the painting. For example, this book is devoted to the 'medium of acrylic'. In its narrower meaning, the word describes substances added to the paint, either during its manufacture or when mixing colour on the palette and that is the kind of medium we consider here.

Because acrylic is water-based, you can thin it by adding more water. This is the only medium you need for early experiments. But there are several mediums made especially for acrylic work that you may find useful later on. They change the nature of the paint in various ways, making it slower to dry, more transparent, or thicker. Based on the polymer emulsion used in the manufacture of the paint, the mediums are white when applied but become transparent when dry. This archival permanence is one reason why many professionals prefer to use a medium rather than plain water.

Left: *All the major paint manufacturers produce the basic acrylic mediums. The packaging varies from tubes to tubs and bottles, but the brands are much the same. However, only one or two manufacturers make mediums for special textures, so you may need to seek these out.*

ARTIST'S TIP

Even the heaviest impasto acrylic paintings will be thoroughly dry and ready to varnish after several weeks' drying time. When you are ready to start varnishing your acrylic paintings, you may want to practise applying the varnish on a test surface first. There is as much artistry to applying varnish as there is to creating a painting, so it is good to practise this process, too.

What does gloss medium do?

Acrylic gloss medium increases the translucency and gloss of acrylic colours while reducing consistency to produce thin, smooth paint layers which dry rapidly. This means that an unlimited number of glazes of exceptional brilliance, depth and clarity can be developed and exploited.

A few drops of the medium mixed with watercolour or gouache transforms them into an acrylic paint; that is, they take on many of the characteristics of acrylic paint: quick-drying, water resistant, capable of overpainting without picking up and a gloss finish.

The acrylic gloss medium is an essential part of the acrylic artist's paintbox, as essential as water itself, for nearly all the main tasks that acrylic paint is capable of achieving are much better done with a few drops of the medium added to the paint or wash.

This medium has a secondary function as a gloss varnish though there is a newer and more practical and versatile product in two finishes, gloss or matte, which can between them furnish a glossy, semi-matte or eggshell, or matte finish to acrylic paint (*see page 60*).

Left: *This is mainly used for glazing methods. It makes tube colours thinner and more transparent, so that they can be built up in successive layers.*

ARTIST'S TIP

Acrylic paint manufacturers recommend that you never add more than 50% water to your paint mixes or they may not adhere to the surface permanently. However, they claim that you can add as much medium as you like since a medium is essentially the same as paint, only colourless.

How is matte medium different from gloss medium?

The matte medium behaves in a similar way to the gloss and everything said of the gloss medium also applies to the matte. It is a useful medium to have if you intend to paint matte, so that the tones of the colours can be properly mixed before painting. There is an appreciable difference in tonality between matte and glossy finishes. The pigment dispersed in either medium may be the same for both matte or gloss, but the light affects them differently. To allow for this during painting, the addition of a few drops of matte (or gloss) medium in the paint mixtures will ensure that, on drying, you get exactly the tone or tint you want.

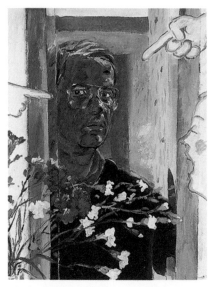

Above: *Self Portrait, Gerry Baptist. A self portrait painted with glazes. The hands and head at the top and right side of this unusual work on canvas board represent an audience – the viewers of the painting process. Most portrait painters are familiar with the experience of would-be helpful remarks made as they work and here the artist has 'painted' in the comments, bringing the viewer into the portrait.*

Above: *Similar to gloss medium, but thicker, because it contains a waxy substance to reduce shine. Use it for glazing if you want a matte surface.*

Will the finished painting really look different if I use a medium instead of plain water?

Yes, if you use a medium instead of water the paint will behave differently and the result will look completely different. Look at the examples below.

You can achieve watercolour-like effects, or lay transparent glazes, simply by thinning the paint with water, but the special glazing mediums (acrylic, matte and gloss medium and gel medium) make the paint more lustrous as well as more transparent. The mediums will even impart a translucent quality to thick or medium-consistency opaque paint – which water will not do – and they give the paint more body, so that it stays in place rather than running down the surface you are painting on.

Left: *The paint on the right was mixed with gloss medium and that on the left with water alone.*

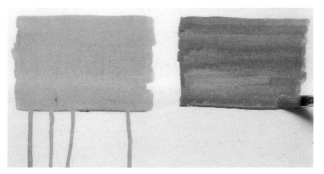

Left: *The watery paint on the left dribbles down the surface, while the paint mixed with matte medium remains in place.*

What is gel medium?

Gel medium is thicker than the gloss or matte mediums. As its name implies, it is jelly-like in texture and consistency, and like the gloss medium it has two distinct functions.

First, it enables thick, highly textured impastos to be produced easily while maintaining consistency of colour; and second, the colours increase in translucency the greater the proportion of gel medium used. At the same time, the drying rate of the paint is retarded to some degree.

Glazes and impastos are an integral feature of acrylic painting and, because of its fairly quick drying qualities, acrylic has an advantage over oil paint, which is by comparison a slow drier, making glazing a drawn-out operation, in which it is hard to foresee the result.

Glazes are made by laying a transparent film of colour over another that has already dried. With oil it may take up to two months for a surface to dry out thoroughly for glazing to be done. With gel medium it can be done in a matter of minutes. Moreover, any number of glazes can be overlaid and not just one, as with oil paint. Glazing is a beautiful way of using acrylic colour so that its brightness and purity is exploited to the full.

Both the acrylic gloss medium and gel medium can be used to make glazes. The difference is merely one of consistency. The gel medium is much thicker than the gloss and therefore can also be used for impastos. Nevertheless it will make beautiful glazes especially with a palette knife.

Impasto is thick paint that can be textured by the movement of the brush or by the edge of the palette or painting knife. Impasto has been a particular characteristic of oil paint and gives tremendous vitality to the expressiveness of the image. Gel medium can achieve this effect in exactly the same way as oil paint, with just as much vitality and is less liable to crack. It dries much quicker than oil so it is less easily spoiled or damaged during painting and, once dried, it becomes very hard to dislodge.

Above: *This jelly-like form of gloss medium, thickens paint for impasto effects and does not affect the translucency of the colour.*

What is retarding medium?

An acrylic retarding medium is designed to prevent the water in the paint from evaporating quite so quickly. Acrylic artists say this increases the 'open' or drying time of the paint, which will allow you to employ some traditional oil-painting techniques, such as painting wet-into-wet. Depending on how much retarder is used, it can extend the working time of the paint by about half an hour.

Above: *Used by artists who like to achieve oil painting effects, this slows the drying time, so that colours can be blended.*

What is flow improver?

As the name suggests, a flow improver medium thins the paint and enhances its flow but without diluting the strength or intensity of the colour the way plain water does. Mixing flow improver into your paint also allows the paint to flow more freely off your brush, which may mean you will need to modify how you apply the paint.

Right: *Also known as flow enhancer, this is a solution of wetting agents that helps to break down the gel structure of acrylics.*

What is texture paste used for?

The thickest and the most powerful acrylic binder comes in a carton. Though more dense than the other two binders, it can be watered down without any loss of its adhesive powers.

It can be used to make those very heavy impastos that Vincent Van Gogh was so fond of. For this kind of vigorous brush stroke, large brushes will be needed, or a palette or painting knife will serve just as well.

Alternatively, instead of using this medium to make thick coloured impastos, it can be formed so that other materials, for example sawdust aggregate, may be pressed or embedded into it, to create richly textured surfaces.

The Tepline paste medium has remarkable adhesive powers and so presents numerous possibilities for design, one of which is the pleasant and simple assemblage known as collage. It presents many possibilities for design and can be used to model and, with the addition of sand, marble dust, or other aggregate to strengthen it, it can be carved or cut and even sanded when dry.

Above: *Also known as modelling paste, a very thick medium for heavy impastos and special texture effects.*

How much medium should I use?

To some degree, how much you use depends on your personal preference, which you can only learn through trial and error. But to start, you might try mixing equal parts paint and medium, then experiment using more and less.

Are there other mediums available?

Indeed, yes and new products come out from time to time, too. New mediums are often combinations of existing mediums, giving you combined properties. I recommend researching mediums and their uses by going to the major manufacturers' websites for additional information.

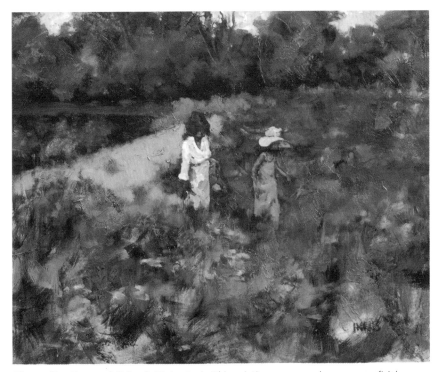

Above: Two Figures, Still Pond, *W. Joe Innis. This painting on canvas bears a superficial resemblance to an oil painting, but closer examination reveals effects that are special to acrylics. The artist achieved a lively surface through varied brushwork and contrasting paint consistencies. Also, an extra dimension of texture was created by working over a textured ground made from a combination of acrylic modelling paste and sand applied with a knife. To increase the surface contrast, the texture was restricted to certain areas.*

How do I mix any of these mediums into my paints?

I recommend using a painting knife to thoroughly blend the medium into your acrylic paints after you have mixed your desired colour. Of course, you can then continue to add more paint to modify the colour as you continue to apply it. You can apply the paint with the knife or with your brush, depending on the look you want to achieve.

Above: *A painting knife is used to mix paint and gel in equal proportions.*

ARTIST'S TIP

Many artists' painting brushes are made from natural animal hair, such as squirrel or sable. Much like human hair, the natural materials in your brushes are delicate, which means they can become worn down with rough use. That's why it is best to avoid 'scrubbing' your acrylic paints into your surfaces with your expensive, natural-hair brushes. Also, some of the texturising mediums contain a lot of gritty materials that can be hard on delicate, expensive brushes. It is best to mix the medium into your colours and to apply the paint/medium mixtures with a palette knife or an inexpensive brush.

Above: *The consistency of the gel is thick and so it will retain the shape of the knife marks.*

Should I apply varnish to my finished acrylic pieces?

It is not absolutely necessary to varnish your finished acrylic painting, although a protective coat is sometimes a good idea. Varnishing was traditionally used on oil paintings to preserve the surface, but acrylic paint is durable and can be washed with soap and water, hence eliminating the need for such stringent precautions.

However, it should be mentioned that the surface of the picture can be enhanced by giving it a coat of medium or varnish, both of which come in either a gloss or matte finish. Other alternatives are a soluble varnish, removable with turpentine, or a coat of acrylic fixative, which gives a protective sheen to the picture surface.

If I decide to varnish a finished painting, should I use gloss finish or matte finish varnish?

As with mediums, the finish you use is a matter of personal preference. However, If you find that a glossy finish is too shiny, or a matte one too bland, there is a way of making an intermediate finish. Simply blend the gloss varnish with the matte in a saucer, or container and brush on as directed. The resultant midway finish can be adjusted to suit individual preferences by adding either more gloss or more matte varnish to the mixture.

Left: *Acrylic varnishes are made in matte and gloss versions. Their main function is to protect work from discolouration caused by dust and other pollutants. It is wise to varnish a painting that is to be hung and framed without glass.*

Do you have any tips or advice for applying varnish?

Yes, definitely! Varnishing with acrylic matte or gloss varnish should present no difficulty provided these ten points are followed.

1. Varnishing can be carried out with undiluted medium, straight from the bottle, but it is a more practical and safer, practice to pour a little medium into a clean saucer or container and add a few drops of water to thin it slightly. This slows the drying rate, enabling you to carry out the operation without haste.

2. Always varnish, if possible, with a soft brush. A hard brush may leave brushmarks, which will look unsightly. Wash brushes immediately after varnishing. Dried varnish is very hard to remove and if left may harm the brush.

3. To be quite certain of completely covering the surface with varnish, look obliquely along the work. Any untouched areas will be detected immediately because of the reflected light and varnish applied.

4. Discard any unused varnish and use a fresh supply each time.

5. Although the varnish has no smell to speak of, there is no reason for leaving the screw-cap off when not in use. The water in the medium will evaporate fairly quickly and if it does, the varnish will no longer do its job properly.

6. The surface to be varnished must be absolutely dry – that is, dry all the way through – otherwise the varnish will pick up and spoil the look of the work. Acrylic paint dries fairly rapidly and it should not prove too difficult to determine whether the paint is fully dry or not. Nevertheless thicker coats of paint, like impastos, may be deceptive. The best rule is to leave it for a week or so to make absolutely certain.

7. Ensure that the work to be varnished is clean. Specks of dust and other unwanted particles can appear from nowhere, so gently brush the surface with a clean, soft rag or soft brush prior to varnishing.

8. Always varnish in a clear atmosphere. Do not carry out the job, for example, in a room where any sawing, planing or sanding has taken place. Once grit or dust gets into the varnish it is difficult to remove without damage to the paint and a great deal of time-consuming trouble.

9. Do not hurry the job; take plenty of time to do it properly. Put aside the work to be varnished until it can be done without haste.

10. Never under any circumstances use acrylic varnish over oil paint.

Varnishing is a normal part of painting with acrylic and should offer few

problems if these ten points are scrupulously observed. If in doubt, the best procedure is to try the varnishing exercise with the medium on any and every kind of expendable surface available. Paintings that have been discarded make a useful beginning; or splash some acrylic paint on a piece of card or paper and experiment by varnishing them when dry. It should not take long to grasp the principle of varnishing with a soft brush.

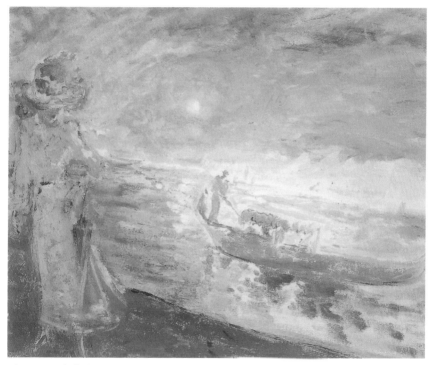

Above: Interlude in Venice, *John Rosser. As it dries quickly, thinly applied paint such as that used in the painting above can be varnished soon after the work is completed.*

5

CHOOSING AND PREPARING A PAINTING SURFACE

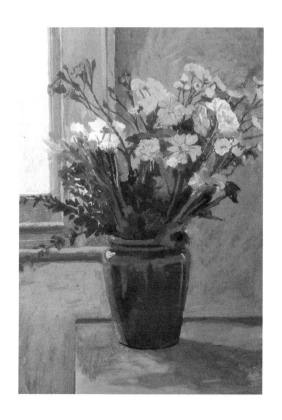

What types of surfaces can I use to paint on with acrylics?

Finding 'something to paint on' is not usually a problem when using acrylics because you can work on almost any surface you choose. Canvas, hardboard and paper are the choices which come immediately to mind, but there is a surprising variety of more unusual supports which are just as suitable. Wood, metal, plastic and various fabrics have all been used successfully and it is this versatility which has made the paint so popular with so many artists.

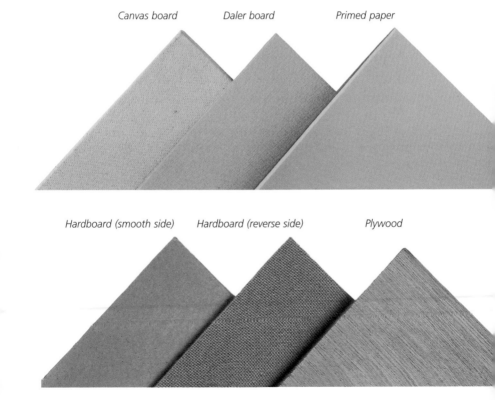

Canvas board Daler board Primed paper

Hardboard (smooth side) Hardboard (reverse side) Plywood

Can I paint on anything with acrylics?

No, there are a couple of exceptions. Acrylics will not adhere to any surface that contains oil or wax. This fact rules out any canvas or board that has been primed with any oil-based primer or with rabbit-skin glue. If you use a surface that has any oil in the primer, then sooner or later the paint will come off.

Very shiny surfaces can also cause problems. Many artists do use acrylic on metal, plastic and glass, but the colour can sometimes be scratched or peeled off. It is therefore a good idea to roughen the surface before applying the paint. If you have ever cleaned an acrylic palette, for instance, you will know that it is quite possible to peel or scratch dried paint off a smooth, plastic surface, however difficult and time-consuming this may be. A quick 'roughening' with sandpaper or glasspaper will provide the support with a 'tooth' for the paint to adhere to, ensuring that the colour remains intact.

Can I just use the prepared canvasses found in art supply stores?

Yes, of course! Primed boards, canvasses and muslin-covered supports are available from art shops. Just make sure you purchase surfaces that are made especially for use with acrylics because they are primed with acrylic gesso.

ARTIST'S TIP

Whether you're painting on board or on canvas, you can get the exact surface you want by working with the gesso primer. If you want a super-smooth surface, apply several layers of gesso primer, allowing each layer to dry thoroughly and then sanding until smooth with fine sandpaper before applying the next layer. At the other end of the spectrum, you can create a highly textured surface by applying the gesso thickly and using any number of techniques to create texture while you apply it. Run a coarse bristle brush through it, stamp into it with a texture surface, or be creative with your texture-making techniques. Just allow the gesso to dry thoroughly before you start applying the paint.

What are the advantages and disadvantages of using prepared canvasses?

Bought surfaces are quick and convenient, especially if you prefer to work on a fairly small scale. But the sizes and shapes of ready-made supports are limited and they are by far the most expensive type of painting surface. A good alternative is to buy acrylic primed canvas off the roll. Art shops sell this by the metre, often in a choice of two thicknesses – 'standard' and 'double'. The 'double' quality is recommended for large-scale works and murals.

Are there less expensive alternatives to stretched canvasses that I could use?

Absolutely. If you want to work on canvas but do not want to spend a lot of money, you can prepare your own surfaces.

There are a number of perfectly satisfactory surfaces which are both quick to make and inexpensive. For inexperienced painters who are new to the medium they are particularly valuable as it can be both costly and intimidating to start each picture on a canvas which has been specially bought or stretched for the purpose. One of the best of these is hardboard. Many professional painters actually prefer this to canvas and it is certainly worth trying. Most artists paint on the smooth topside of the board but there is no reason why you cannot use the reverse side if you prefer a rough texture. Large pieces of hardboard tend to be unwieldy unless they are batonned from behind to stop them from bending. They can be primed with acrylic gesso if you prefer a white support, or you can seal the surface with acrylic medium, thus preserving the natural colour.

Acrylic medium can be used to stick muslin, scrim or any other fabric to a rigid surface such as hardboard or wooden panelling. This produces a texture similar to stretched canvas and can also be treated with acrylic gesso or one of the transparent mediums.

Below: *A selection of ready-prepared canvasses and canvas boards is available, or you can make your own (see* opposite page*). Try out different surfaces to discover which you like. If you find that a non-textured surface suits you, the smooth side of Masonite is a good choice.*

Stretched and primed linen canvas, coarse grain.

Stretched and primed human-made fibre canvas, fine grain.

Stretched and primed cotton canvas, medium grain.

Canvas board, primed for acrylic work.

Masonite, smooth side. Can be sanded down before priming to remove the sheen.

Masonite, rough side. This is only suitable for thickly applied paint and rugged effects.

What if I really do not want to spend a lot of money on supplies?

A good rule to follow when you begin painting in acrylics is never to throw things away. Keep packaging materials, such as brown wrapping paper and cardboard, as these make attractive painting surfaces. Use the matte side of wrapping paper and treat brown cardboard with acrylic gesso. Paint on inexpensive plain wallpaper sold for walls and try out your brushwork and colour mixes on old newspapers.

Another material often used for acrylic work is Masonite, which is available from building supply centres. This has two major advantages: it is inexpensive and you can cut it to whatever size or shape you like, whereas specialist painting boards are made in standard formats. Masonite has a shiny surface, but you can counteract this by sanding it lightly before priming with acrylic gesso.

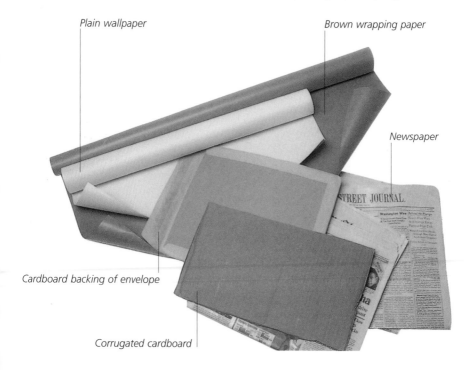

Plain wallpaper

Brown wrapping paper

Newspaper

Cardboard backing of envelope

Corrugated cardboard

Could you tell me more about preparing one of these Masonite boards?

Sure. Let me give you a quick demo:

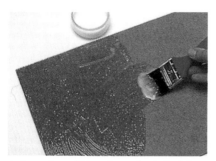

1. Cut a piece of Masonite to the desired size and spread it evenly with a layer of acrylic gloss medium.

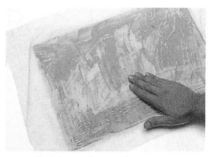

2. Cut the fabric with enough surplus to take around on to the back of the board. Place it on the glued surface and smooth with your hand.

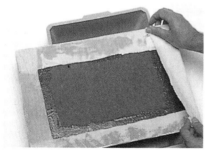

3. Turn the board over and raise it off the table so that it does not adhere. Glue around the edges and stick the fabric down, folding it in at the corners.

> **ARTIST'S TIP**
>
> Masonite panels can be fairly thin and if paintings done on thinner panels are stored or hung in any kind of damp or humid areas, they can warp slightly. To help prevent warping, some professionals recommend applying a thin coat of acrylic gesso to the back side of the panel. This works for all other gesso-coated panels and boards as well.

Why do you recommend sealing these surfaces with acrylic medium?

An ideal surface for acrylic paints is one which is slightly porous, absorbent enough to provide a 'tooth' for the paint to adhere to, yet not so porous that it becomes difficult to apply the paint. A support or surface which is too absorbent can normally be given a coat of acrylic medium to seal it. The medium leaves tiny pores which provide sufficient 'tooth' to allow the paint to cling to the sealed surface.

Supports can be sealed with a gloss or matte medium depending on the type of surface required. Both are colourless and therefore especially useful when you are particularly anxious to preserve the colour of the support – cardboard or tinted paper, for instance, would be ideal if you wanted to incorporate their colour into your picture. If the medium is applied thinly it will not spoil or obliterate the texture of the surface.

Can you suggest any other inexpensive alternatives?

Sure, here's another idea: Cardboard and stiff paper are perfectly suitable for acrylics, treated or otherwise, although if you are using diluted acrylics to achieve a watercolour effect, it is advisable to stretch the paper first to avoid wrinkling. This can be done by soaking a good

quality watercolour paper and sticking it to a drawing board with gummed paper tape. Allow a good margin of tape to cover both the paper edge and the drawing board. The paper should be allowed to dry naturally before it is used for painting.

What kind of watercolour paper do you recommend?

Three types are available: rough (not pressed), medium rough (cold pressed) and smooth (hot pressed). Rough is not easy to use because you need a lot of paint to cover the texture. Cold pressed,

has enough texture, or 'tooth', to hold the paint in place, but hot-pressed paper or smooth matte board gives interesting effects. The paint slides around more, so you can exploit the effect of brushmarks.

Can I paint on pastel paper?

Yes. You can paint on pastel papers. These are made in two textures and a wide variety of colours. They will need to be stretched to prevent them from buckling when they become wet. You must do the same if you want to try painting with acrylics on lightweight watercolour papers.

A wide range of papers and boards are available. They all have different characteristics, so experiment with several.

White matte board

Off-white matte board

Deep cream matte board

Smooth (hot-pressed) watercolour paper

Medium (cold-pressed) watercolour paper

Rough watercolour paper

Mi-Teintes pastel paper, beige

Mi-Teintes pastel paper, grey

ARTIST'S TIP

One of the challenges of working on unprimed paper is that the absorbency of the surface will make your paint dry more quickly than ever. To overcome this problem, consider using a heavyweight paper, such as 300-pound watercolour paper and dampening it before you start painting. The water in the damp paper will give you added time for blending.

Are paper surfaces durable enough to stand up to the acrylic in the paint?

Yes, in fact, these papers could be considered more compatible with acrylics than with watercolours or pastels. Good-quality watercolour and pastel paper are acid-free, which prevents the fragile watercolour and pastel pigment from possible spotting or discolouration over time. But the tough skin formed by acrylic paint seals and protects the paper, so your work will not be harmed by a slight acid content. This means you can use less expensive surfaces.

Could I economise by stretching my own canvas?

Certainly. There's a little more work involved, but it is a cost-saver. Stretching and preparing your own canvasses can be fun and it is certainly the best way of making absolutely sure that your support fits your personal requirements.

You will need a wooden frame, or stretcher and a length of canvas to cover it. The canvas can be attached to the wood with tacks or staples. The best way to make a stretcher is to buy the wooden sides and fit them together. These stretcher pieces are sold in most art shops and come in different lengths, giving you a choice in the size and proportion of your support. Make sure the shop gives you eight 'wedges' for every stretcher you intend to make. When the stretcher pieces are slotted together, these tiny wooden pieces fit into the corners and can be adjusted to keep the fabric taut.

ARTIST'S TIP

Trying to economise on painting supplies, especially when you're just learning, is understandable. But most artists would recommend that you steer clear of student-grade paints and use professional quality right from the start so that you really get to know the medium in all its glory. However, you can save money by buying paint colours labeled 'hue' or 'imitation'.Most of these substitute expensive natural pigments like cadmium with a synthetic replacement. These are often every bit as strong and beautiful as their 'real' counterparts, but far less expensive.

HOW TO STRETCH YOUR OWN CANVAS

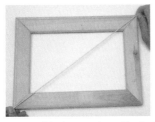

1. Assemble the stretchers. Check the corners are true 90° angles by stretching a piece of string across diagonally. Adjust if necessary.

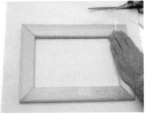

2. Place the stretcher on the canvas and cut canvas to size, allowing sufficient fabric at the edges to fold on to the back of the stretchers.

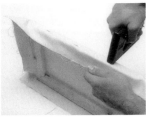

3. Staple or tack one long side of the canvas to the edge of the stretcher. Then turn it over, pull the canvas with your fingers and staple the other side. Repeat for the short sides.

4. Staple or tack the canvas on to the back of the stretchers, leaving at least 5cm (2in) free at the corners. To mitre the corners, turn down the canvas point to form a pleat on either side.

5. Fold down the pleats and tack or staple through all thicknesses. If tacking, use two tacks. If using a staple gun, place the staple diagonally, with one end in each stretcher.

6. Prime the canvas with acrylic gesso, using a household brush. If you prefer the natural colour of the canvas, prime it with acrylic matte or gloss medium (*see pages 59 and 60*).

Can you tell me more about priming the canvas?

Also called acrylic primer, the luminosity of a bright acrylic gesso undercoat brings out the vividness of the paint, enhancing the colour and adding translucence to thin washes.

Unlike traditional gesso, acrylic gesso is very flexible and can be used on canvas without risk of it cracking or chipping.

Acrylic gesso is a mixture of medium and white pigment and comes in jars ready to use. Like acrylic medium, it does not affect the texture of the support if applied thinly. It can also be used on wood, paper and almost any other surface, provided that it is free of oil or wax.

Any guidelines or tips on applying the gesso to the canvas?

If you use a brush to apply the gesso it may be necessary to add a little water. You will probably need two coats of gesso to get a really even surface. Use a stiff decorator's brush to work it into the canvas weave.

An alternative method is to use a putty knife. Starting from the centre, add a little gesso at a time and spread it outward with a fairly wide putty knife. The mixture should be forced gently into the weave of the canvas, any excess being scraped off and applied elsewhere. The knife should be held at an oblique angle to prevent the sharp edge from cutting.

Do I have to use canvas, or are there other fabrics I could use?

There is a wide variety of fabrics to choose from. Most of them are cotton or linen. Linen is generally the best, but it is also the most expensive. It is often handmade and has a fine, slightly irregular weave which makes it both easy and interesting to paint on. Cotton is softer and bulkier with a regular, machine-made texture. It is lighter in colour than the linens and usually less taut when stretched and primed. Both come in different weights.

Or for something different, try embroidery linen or calico, which are relatively smooth; or hessian and flax which have a coarse, open weave.

Is it necessary to prime the canvas?

No, but you will get a distinctly different look. This is *Spawn*, by Morris Louis (1912–1962), one of the early innovators in acrylic fine art painting. In this painting the diluted colour was applied directly on to unprimed canvas, producing the 'stained effect' that is now synonymous with his work.

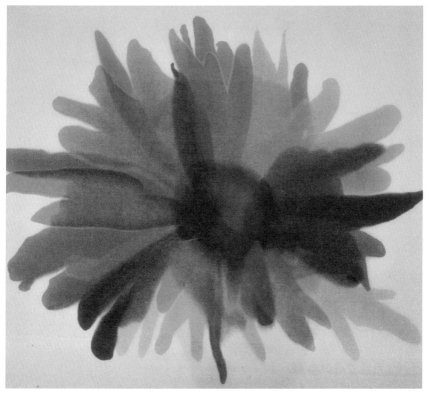

Above: *American Morris Louis was one of the first artists to experiment with acrylics. His painting* Spawn, *which he created in 1959, is typical of his work in the medium.*

CHAPTER

6

FAMILIARISING YOURSELF WITH YOUR MATERIALS

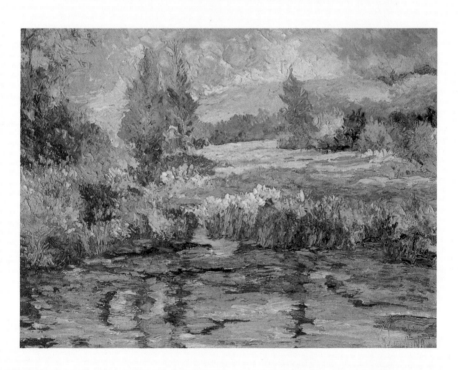

I've never used acrylics before. Where do I begin?

To start, become familiar with them by experimenting on some inexpensive watercolour paper before you embark on a painting. Start by exploring the different consistencies of paint. Dilute it with water, so that it resembles watercolour and then progress to thicker applications. This will help you discover the qualities of the paints and begin to find out how you might prefer to work.

By starting with water-thinned paint and no additional white, you will learn a lot about the colours themselves and how they differ. Set out all your starter palette colours, mixing each one with water in roughly half-and-half proportions. You will see that some colours are naturally much darker than others and some have a slightly chalky consistency.

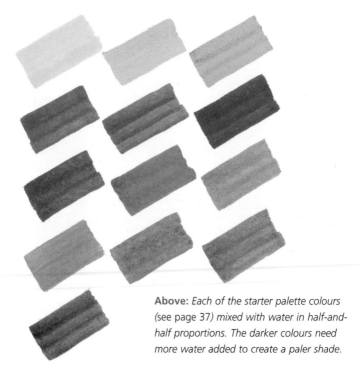

Above: *Each of the starter palette colours (see page 37) mixed with water in half-and-half proportions. The darker colours need more water added to create a paler shade.*

How much water should I use?

It takes a little practice to learn how much water to add to a colour to lighten it, so when you are painting, test mixtures on a spare piece of paper first. These examples show phthalo blue, a very strong colour and yellow ochre, a relatively weak one, mixed with varying quantities of water. Keep in mind that paint manufacturers recommend that you never use more water than paint in your mixture. If you need more than half liquid to get a light enough tone, you may want to use medium instead of water. The colour at the top in each case is the pure tube colour applied with a lightly moistened brush.

Pure tube colour *25 per cent water*

50 per cent water *75 per cent water*

Does it matter what brush I use for these experiments?

No, but I recommend using a broad, flat brush *(see page 44)*. This is a good opportunity to explore ways of applying the paint while you're getting to know how the colours look and interact with each other. Make a flat wash by taking colour over the paper with a broad brush. Then grade the wash from dark to light by adding more water or medium for each stroke. Try making sweeping diagonal strokes and dab colour on to the paper with the tip of a round brush. Lay one colour over another to mix, or dampen the paper so the colours mingle.

Each of the starter palette colours mixed with water or medium in half-and-half proportions. The darker colours need more clear liquid added to create a paler shade.

A flat wash made by taking a broad brush from one side to the other, then recharging it for the next and each subsequent stroke.

A wash graded from dark to light by adding more medium for each stroke.

Sweeping strokes, with each brushmark
pulled out toward the end.

Crisp edges are created by
laying one colour over another
after the first has dried.

A new colour dropped into one that is still
wet, with the paper first dampened.

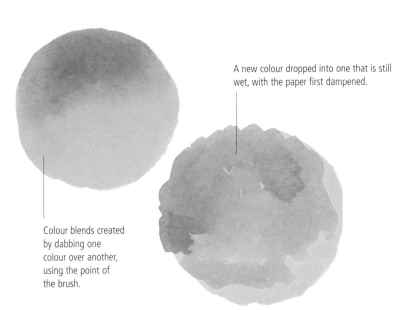

Colour blends created
by dabbing one
colour over another,
using the point of
the brush.

What are the benefits of working with acrylics in a transparent fashion?

One of the great advantages of this is that once the colour is dry, acrylic is insoluble and therefore permanent. This means that your picture is protected from damp – the longstanding enemy of watercolour paintings – and is therefore more durable than the traditional medium. This insoluble characteristic also makes it easier to apply successive washes and will give you maximum control when working with transparent overlaid colour. If you have worked with watercolour, you will know that when you apply one colour over another, the first colour can start to dissolve and blend with the second, thus restricting the amount of colour which can be added before the paint starts to turn 'muddy'. With acrylics this is not the case. The colours remain separate and it is possible to build intricate layers of wash to create complex yet spontaneous effects.

Acrylics have been especially welcomed by those artists who like working in watercolour but feel restricted by the traditional small scale of watercolour materials. With acrylics, the scope is broader – not only does the paint come in larger quantities, but you also have a wider choice of supports. All the traditional watercolour papers are suitable and acrylic washes can be used directly on to fabric – including unprimed canvas – as well as gesso boards and other primed surfaces. Even though you are using acrylic as watercolour, you are at liberty to work on a larger scale than is generally practical with real watercolour.

Above: Anemones in an Earthenware Jar, *Ian Sidaway. Acrylic can be used in thin washes to produce an effect which is almost indistinguishable from watercolour. In this painting layers of transparent washes are applied to create the delicate shades of the flowers and background.*

Do I always have to use a lot of water?

No, not at all. The tube consistency of paint is similar to that of heavy cream, so it can be used without the addition of water. However, a little water is helpful when mixing colours, because it encourages them to blend together and it also makes the paint easier to spread when you are covering large areas.

Left: Brushstrokes of straight tube colour over flatly applied opaque colour.

Do I have to use any water at all?

Technically, no, but I strongly recommend it. Because acrylic is a water–based paint, it is always the practice to wet the brush before use, especially for mixing paint.

As a general rule, never use a dry brush for anything pertaining to acrylic. A dry brush will not allow the paint to flow properly, will alter the drying times so that it will be harder to gauge and will not do a sable brush much good. However, if it does transpire that a dry brush has inadvertently been used, wash it out immediately afterward. (The exceptions to this rule will be seen in the section on scumbling, but here old brushes are recommended. *See page 112*.)

This means acquiring, early on, the habit of constantly dipping the brush in to water and shaking out the excess, before beginning.

You can do the same with a palette knife – always moistening it before use – though of course, the knife will not retain the water to anything like the same degree.

Is there a medium I can use to thin the paint?

Yes. Thin, transparent washes laid over other colours are known as glazes (*see page 114*) and there are mediums sold especially for this kind of work.

Glazing can be done simply by thinning the paint with water, but it is worth trying the mediums, since they give extra body to the glaze, hold the marks of the brush and prevent the thin paint from running down the paper. If you apply a water glaze with the working surface held vertically, it will dribble down, which can be effective – but is not always the effect you want.

A glaze of yellow mixed with gloss medium, laid over thick, opaque colour. Drying time: ½ hour.

Thickened paint applied with a knife, glazed over with water–thinned crimson and then blue. Surface held upright, so that the runny paint settles above the ridges. Drying time for knife work: three hours.

Are some acrylic pigments more transparent than others?

Yes, some acrylic pigments (*see page 24*) are quite transparent while others are fairly opaque. The more you can restrict yourself to these transparent colours the better. You can of course use any colour you choose and there is nothing to stop you from trying out diluted opaque colours, but these can sometimes look chalky and dull – no matter how thinly they are applied – and will deaden the appearance of any colours you have used underneath them.

Will using less water make some of the transparent pigments appear more opaque?

Yes, you can make acrylic colours look more opaque by adding less water and/or adding white (*see page 182*). Let's do some more exercises about opacity.

For this exercise, utilise a minimum of water, dipping the tip of your brush in to your water jar and then in to the paint. For transparent applications colours are made lighter by adding extra water, but when transparency is not required they are lightened with white, which makes them more opaque.

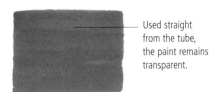
Used straight from the tube, the paint remains transparent.

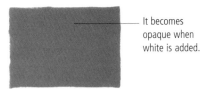
It becomes opaque when white is added.

Is there a medium I could mix in to make a transparent pigment look more opaque?

No, not really, but there is no need to avoid the transparent colours when you want to use an opaque technique. Instead, try mixing in a small quantity of an opaque colour, such as the Titanium White I suggested, or perhaps Mars Black or Raw Umber.

Remember that the gel mediums – both the matte and the gel – will thicken the consistency of the paint but they can also increase transparency if you use too much. Add these mediums sparingly if you want to retain opacity while achieving a thicker texture.

Three similar blues blended by using short, dabbing strokes.

Ultramarine dabbed on with a small square brush. Crimson laid on top in the same way.

What is an easy way to learn which pigments are transparent and which are opaque?

I recommend painting some grids like these to help you to get to know your pigments well.

Although acrylic is technically an opaque paint, the colours will retain much of their transparency unless mixed with white, so a pure red or blue will not completely cover an earlier colour. This is one of the medium's most attractive features, since it allows you to build up effects in layers, with each colour showing through the next. But it can be a disadvantage. When you start to create acrylic paintings, remember not to make any initial brushstroke or pencil drawing too dark or heavy, or you may be unable to paint it out.

Above: *Paint used with a minimum amount of water and no added white. Colours running downward applied first.*

Above: *Pure colours running downward, overlaid with the same colours mixed with white. Covering power is much greater.*

Will applying the paint more heavily or thickly make it appear even more opaque?

Yes. Acrylic paint lends itself naturally to an opaque method of working. The consistency of the paint used directly from the tube or jar is thick and creamy and, if you do not mix this paint with too much water or medium, the colour dries to a dense, smooth finish.

For the inexperienced acrylic artist, using the paint directly from the tube is probably the best way to get acquainted with the medium – especially if you are already accustomed to working with oils or gouache, where a similar technique is used.

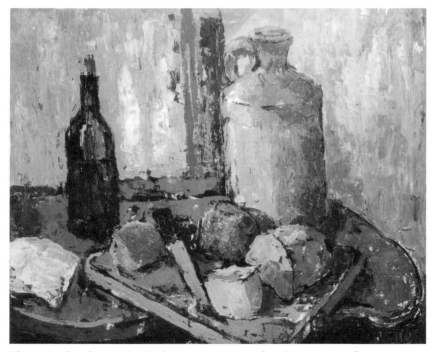

Above: Food on the Farm *by Gordon Bennett. Most acrylic colours are naturally opaque unless diluted with water or one of the various mediums available. Here the artist has taken advantage of this property, applying layer upon layer of colour and texture to create a solid, rugged image.*

Do you have more exercises I could do to learn more about opacity?

Yes, let's repeat the grid exercise with thicker paint so you can learn more.

Unless applied heavily with a knife, even thick paint does not always obscure an underlying colour, especially if the earlier colour is dark or vivid. But you can obliterate a colour by painting over it with thick white and allowing it to dry before applying the new colour. This is useful when a bright colour seems to be losing its clarity because a dark hue is showing through.

Above: *The paint used for the horizontal bands is thick, but a little colour from the vertical bands shows through. Only the chrome oxide green covers them completely, because it is a more opaque pigment than the others.*

Above: *Each of the horizontal bands was given an undercoat of thick white. None of the first colours can be seen through the new ones.*

Does the surface I am painting on affect the drying time?

Yes, on an absorbent surface like watercolour paper or pastel paper, thin washes will dry very quickly (*see pages 78 and 79*). Even heavier applications of paint straight from the tube will be dry within about fifteen minutes. You will have to work quickly if you want to blend colours when working this way.

Two colours worked together while still wet.

Can I use heavy acrylic paint to completely paint over and cover up errors if the pigments aren't completely opaque?

Unless applied heavily with a knife, even thick paint does not always obscure an underlying colour, especially if the earlier colour is dark or vivid. But you can obliterate a colour by painting over it with thick white and allowing it to dry before applying the new colour. This is useful when a bright colour seems to be losing its clarity because a dark hue is showing through.

How can I extend the drying time of the paint?

Even at medium consistency, acrylic paint will harden within about fifteen minutes and less if you are working on an absorbent surface, such as watercolour paper (*see page 78*). But really thick paint takes much longer to dry (approximate drying times are given in the examples here). This allows you to blend and mix colours on the surface by laying them next to, or over, one another while still wet, a method used by many oil painters. You can also build up rich impastos, exploit brushwork to the fullest and apply paint with a knife (*see page 53*).

There are several ways to do this, but let's look at just a couple of easy ways to begin with. First, you will notice that switching to a primed canvas (*see page 82*) or other primed fabric surface will slow down the drying time. Next, experiment with laying on the paint very thickly to see how long the paint takes to dry. You might even want to work 'wet-into-wet' (*see page 107*). This involves laying thick strokes of heavy paint into an existing layer of heavy paint while it is still wet.

Paint straight from tube. Green, yellow and blue blended together while still wet. Drying time one hour.

Paint mixed with impasto medium becomes thicker but retains its transparency. Drying time two hours.

Tube-consistency paint incompletely mixed, so that brushstrokes contain several colours. Drying time one hour.

Building up thickness by laying one coat of tube-consistency paint over another. Drying time between each application half an hour.

Tube-consistency yellow, overpainted with green mixed with impasto medium. Some of the yellow shows through. Drying time two hours.

Can I combine thick and thin applications of acrylics in the same painting?

Yes! This is why acrylic is such a special medium. There is only one other paint that allows you to combine different consistencies in the same painting and that is oil paint. But thin oil paint over thick can cause cracking, so is not advisable. There is no such danger with acrylics, where you can paint heavy impastos over watery washes and vice-versa. But there is one caution. When you are painting over a very thick application, such as one applied with a knife, make sure that the paint is thoroughly dry or you could scuff the surface. You can judge this easily: the paint is dry when it has lost its gloss. Drying times vary from around one to three hours, depending on the thickness. The captions below give approximate times as a guide.

Knife-applied paint over swept brushstrokes of thin, transparent purple. Drying time of thick paint: two to three hours.

Watercolour-type wash overlaid with medium-consistency opaque blue and then thicker knife applied blue. Drying time of knife work: two to three hours.

Brushstrokes of pink mixed with acrylic matte medium, laid over green straight from the tube. Drying time: five minutes.

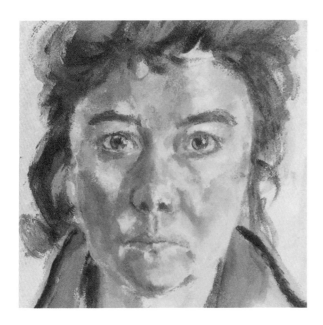

Above: *A portrait. You can use the paint at the same consistency throughout, or build up some areas more thickly, either to give additional emphasis or to provide a contrast of paint textures. The background of a still life or portrait is often painted thinly, as this helps to create the impression of receding space. For this portrait, transparent washes were used for the background and parts of the face; the hair and highlights were more thickly applied. Remember, you can overpaint as much as you like, because once dry, the paint forms an impermeable 'skin'.*

In what other ways does the surface affect the look of the paint?

The kind of surface you work on makes a great difference to the handling of the paint and to the appearance of the finished work (*see pages 72–83*). The paint will glide over a smooth surface, such as primed matte board or Masonite, while the rougher, porous texture of canvas or watercolour paper breaks up the brushmarks, because the paint catches on the raised grain.

It takes longer to cover a textured surface than a smooth one, because you have to push the paint into it. But these surfaces are ideal for broken-colour techniques, because they enable you to apply a colour that only partially covers one beneath.

The other main difference between the various surfaces is their degree of absorbency. Any surface that is not primed (*see page 73*) will absorb the water content of the paints, so that it dries fast. Priming reduces the absorbency by forming a barrier between the surface and the applied colour. Primings vary also and some of the factory–primed canvasses and boards have a slippery surface, which some people like and others find difficult to paint on. What these surfaces have in common is that they are porous. Non–porous surfaces – glass, plastic – will not take acrylic paint.

The choice of surface depends upon your method of working, so the only way to discover what suits you is by trial and error. If you painted in oils before and want to use the same techniques, canvas or canvas board are obvious choices. If you previously used watercolours, continue with watercolour paper for the time being. But if you are new to painting, with no prior experience to guide you, try out as many surfaces as possible, starting with the inexpensive ones, such as Masonite, matte board, and paper.

ARTIST'S TIP

If you're looking for additional inspiration and instruction, you need only go to your computer and use a search engine to search for the key words 'acrylic painting'. Many of the manufacturers' websites provide comprehensive and reliable technical information and there are literally dozens of demonstration videos, blogs and discussion forums on communal artists' sites that will provide you with endless motivation. Along the way, you will enjoy meeting fellow acrylic painting enthusiasts.

UNPRIMED WATERCOLOUR PAPER
Thinned paint spreads easily, but thicker paint needs to be worked into the surface.

PRIMED WATERCOLOUR PAPER
The priming makes it easier to spread medium–thick paint, but thin paint does not go on so evenly.

PASTEL PAPER
The slight texture makes it a good choice for gouache–type effects. Should be stretched before use, or may buckle.

ACRYLIC SKETCHING PAPER
Nonabsorbent, slightly slippery. Difficult to apply flat paint, but shows brushmarks well.

PRIMED MASONITE, ROUGH SIDE
Not a common choice, but worth trying for thick applications. Heavy texture can be reduced by sanding.

PRIMED MATTE BOARD
Easy to spread paint, ideal for smooth paint applications and glazing methods.

PRIMED CANVAS
Traditional surface for oil–painterly effects, but also takes transparent colour well.

PRIMED MASONITE
Nonabsorbent. Easy to spread the paint, but thinned paint forms streaks.

CANVAS BOARD
Primed during manufacture. Cheaper than any ready–made canvas.

7
MASTERING BASIC
TECHNIQUES

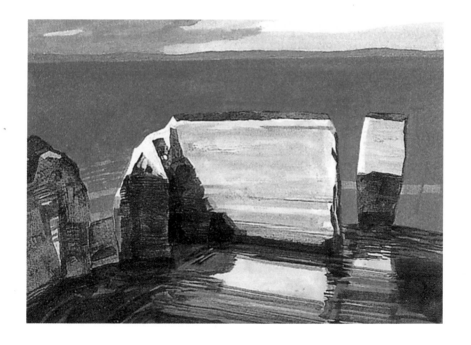

Is it true that it is nearly impossible to blend acrylics because they dry so fast?

No! While blending can be challenging, it is possible – you just have to learn how.

Blending means merging one colour or tone into another so that there are no perceptible boundaries between them. Because acrylic dries fast and can only be manipulated on the painting surface for a short time, it lends itself less readily to blending techniques than other paints.

The method depends on the kind of painting you are planning. If you are using very thin acrylic and aiming at a watercolour effect, you can blend colours by dampening the paper and painting wet-into-wet (see *opposite*), which will spread and diffuse the colours so that they run together.

This method is excellent for vague, atmospheric effects, but less suitable for modelling form, when you need more precision. If you want to merge two colours in one area of a picture – perhaps a vase in a still-life – lay down the first colour and brush over the edge lightly with clean water so that it is still damp when you put down the next colour.

Will adding a medium help with blending?

Yes, that's also a possibility. The thicker you use the paint, the longer it will stay wet, making blending easier. However, you can prolong the drying time even further by adding retarding medium (see *page 63*) to the colours as you mix them. This will allow you to 'push' one colour into another.

Are there any other blending techniques?

Yes, you could also try dry brushing, a technique common to all painting media. It means working with a minimum amount of paint on the brush so that the colour below is only partially covered.

For thin acrylic, you will need to use a soft brush, ideally a flat-ended one, with the hairs splayed out slightly. Experiment beforehand; it is important to get the right amount of paint on the brush or it will be too heavy and spoil the effect. If the painting is in thick or medium-thick acrylic, use a bristle brush; the fan-shaped ones sold as blending brushes are useful. You can brush equally thick, fairly stiff paint over the underlayer, or use thin paint over thick, depending on the effect you want to achieve. (For information on brushes, see *pages 41-50*.)

Can you show me an example of the wet-into-wet blending technique?

Of course! Here's a quick demonstration of achieving soft edges with a wet-into- wet technique similar to what a watercolourist would use.

1. Using a diluted mixture of raw umber, burnt sienna and deep violet, the artist blocks in the plowed field in the foreground. Colour is spread quickly to prevent tide marks and blotchiness as the paint dries.

2. A darker tone of the wash colour is used to paint the furrows. This is done before the wash is completely dry, allowing the new colour to blend in slightly, thus preventing a hard, unnatural edge on the furrows.

3. The first row of trees is added in Hooker's green. This strong colour ensures that they will stand out clearly from the distant trees on the horizon to be added later. The colour is allowed to run slightly into the field colour, thus preventing a harsh outline.

4. The far fields are painted in bright green and cadmium yellow, applied as flat shapes. No attempt is made to create distance by grading the colour to indicate recession. The artist relies on the optical effect of the receding lines on the fields to convey space and distance, even though the furrows converge only slightly.

Can you recommend an exercise that will help me master some of these blending techniques?

Yes, this demo will show you how to do some of them.

1. The paint has been mixed with retarding medium and remains wet for long enough to blend one colour into another with a finger. The working surface is canvas board.

2. Paint the darkest and lightest areas of the aubergine first to help judge the strength of colour for the pepper, which is initially blocked in with brush strokes following the forms.

3. A finger is used to blend one colour into another. The gradations of tone on the pepper are quite subtle.

4. Further dark colours are applied to the aubergine. A nylon brush is used throughout, as this is softer than a bristle brush and does not leave pronounced brush marks.

5. Yellow has been added to the basic red mixture to produce a brilliant orange-red, which is now stroked gently on to the side of the vegetable. The retarding medium makes the paint more transparent so that new applications do not completely cover the underlying colours.

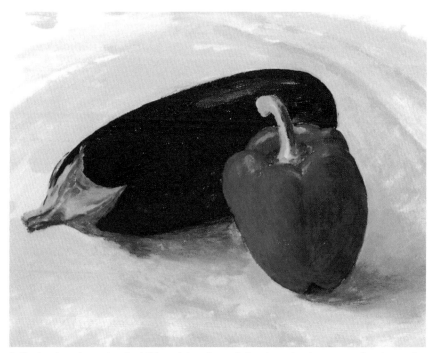

6. The brush marks are barely visible and there is no obvious boundary between each colour and tone. Although retarding medium is helpful, it needs to be used with caution. On a nonabsorbent surface such as primed canvas board, the paint remains tacky for some time and there is a danger of accidentally lifting off small areas of colour.

I have heard artists say that colour can be blended 'optically'. What does that mean?

Essentially, this refers to laying down strokes of colour and allowing the colours to be blended by the viewer's eye. It is known as broken colour.

Broken-colour effects are most often seen in opaque techniques. If you look at landscape painting in thick acrylics or oils, you will probably see that any large area of sky, sea, or grass consists of many different but related colours. Examine close up a sky that simply looks blue from a distance and you may be able to identify a wide range of blues and possibly some mauves, greens and touches of brown as well. These colours all mix in the eye to read as blue.

Broken-colour effects are often created by working on a coloured ground that is only partially covered by the paint, or by laying down a layer of flat colour and working over it with other colours. Acrylic is particularly well suited to the latter method, as the first layer of paint will dry quickly.

The broken-colour approach sounds interesting. How can I learn to use it?

Here's another demo that you could follow that will help you learn this technique.

1. The composition is roughly mapped out with a few linear brush strokes. Small, separate areas of colour are applied. The work is on heavy, moderately textured watercolour paper.

2. For the sun-struck white areas of the building, thick paint is used over the earlier thin washes.

3. Although the painting is built up with a patchwork of colours, take care to establish colour relationships, repeating the blues and yellows from one part of the picture to another.

4. In an architectural subject it is important to maintain correct perspective and straight verticals. Use a piece of spare board as a ruler, with the brush drawn lightly along the edge.

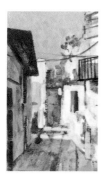

5. Vary the paint surface. On the buildings particularly, transparent washes in the shadow areas contrast with thicker paint, where the grain of the paper breaks up the brush strokes to give a textural effect.

6. The painting is nearly complete, but the foreground is not yet sufficiently strong. Use a large soft brush to lay washes, or glazes, of thinned paint, which create pools of deeper colour.

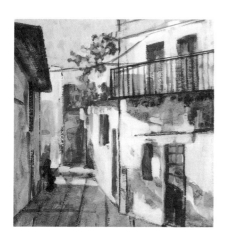

7. In each area of the picture, both the colours and the brushwork are nicely varied and the contrast between thick and thin paint adds to the lively, sparkling effect.

Broken colour sounds a little like a technique known as 'scumbling'? Are they similar?

Scumbling is somewhat related to broken colour, except that it tends to result in a much softer look.

Scumbling involves scrubbing an uneven layer of paint over an existing colour. Scumbling is much used by oil painters, but since the underlying layer must be completely dry before the scumbled paint is applied, the method is even better suited to fast-drying acrylic. Indeed, it is such a natural way of working in acrylic that artists will sometimes be unaware that what they are doing constitutes a technique.

Whether you choose to scumble a contrasting colour or a similar one depends on the effect you are seeking. You might, for example, scumble several subtle colours over a base coat of mid-grey to suggest the texture of a stone wall, or you might enrich a vivid colour, such as a deep, bright blue, by scumbling over it with shades of violet or lighter blue.

Left: *Scumbling is an imprecise method, impossible to restrict to a small area, so before turning her attention to the sky, the artist has protected the area by covering it with tape. When the tape was removed it left a crisp edge. Masking tape was also used to protect the margins of the paper, which resulted in a perfectly defined straight edge that complements the edge qualities in the painting and contrasts with the soft, broken-colour effects of the scumbling method.*

Can you show me how scumbling is done?

The most important thing to remember is that you should not cover the colour beneath completely, so the paint is usually applied with a light scrubbing action – using a stiff brush, a rag, or even your fingers. If you are working on canvas or canvas board, the grain will help you, because the paint will be deposited only on top of the weave, but scumbling can also be done quite effectively on a smooth surface such as primed hardboard.

Generally the acrylic paint is used fairly thick, but you can scumble with water-thinned paint provided you follow the dry brush procedure (*see page 106*) and squeeze most of the paint out of the brush. You can also make semi-transparent scumbles by mixing the paint with gloss or matte medium.

1. Lay flat base colour and allow it to dry. Using unthinned paint and a bristle or synthetic brush, apply a paler mauve-blue lightly over it. Vary the direction of the brushstrokes and leave patches of the first colour visible between them.

2. When the first scumbled layer is dry, introduce a third colour, such as cerulean blue. Take care not to cover the first colours completely.

3. The effect comes from the way one colour shows through another colour.

Glazing is a technique common to both oils and watercolours. Can I glaze in acrylics?

Acrylics are great for glazing, but it is important to know what you're trying to achieve with a glaze (*see page 116*) before beginning to apply it.

A glaze is a transparent film of paint, usually applied over another colour. It can change the underlying colour without obliterating it, producing a subtle film-like quality instead of a flat opaque finish. If the glaze is to show up clearly, the underlying colour must be paler than the glaze itself.

Occasionally a light coloured glaze is used over a colour that is the same tone, or perhaps even darker, but in this case the result will always be subtle, adding a barely noticeable sheen to the glazed area rather than actually changing its colour. The strength of a glaze depends partly on the staining capacity of the particular pigment you are working with and partly on how much water or medium (*see pages 58-66*) you use to dilute the colour. Some pigments produce a stronger tint than others. For instance, phthalo-cyanine green makes a bright glaze that will tend to dominate the colour underneath; a colour with low tinting strength, such as raw umber, will tone down or modify the underpainting without overpowering it.

Left: *You can dilute the glaze with water or acrylic medium – medium produces a richer, livelier colour – and apply this over the underpainting. If a thicker glaze is desired, build up the colour in several thin layers.*

What's the best way to mix a glaze?

If you use water by itself to dilute the colour, the glaze dries to a dull, matte finish. When the paint is diluted with acrylic medium (*see pages 58-63*), it dries gloss or semi-gloss, depending on how absorbent the surface underneath is. A glaze mixed with medium is usually richer than one mixed with water, but the dullest of finishes can be enlivened and the colour brought up to its full potential, by applying a coat of acrylic varnish, gloss medium, or acrylic fixative.

Will the glazing medium affect the colour?

Yes. Although transparent glazes will not cover a colour beneath – this is not their purpose – they can significantly affect the colour. A glaze of yellow, for example, gives a greenish tinge to blue. Colours can also be lightened by glazing; in the grid below, the black at bottom right has become grey.

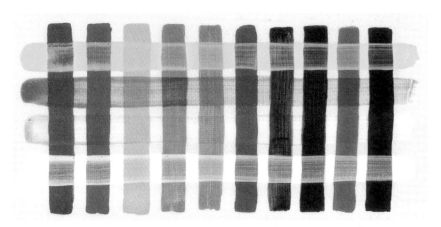

Above: *For the horizontal bands, the colour was mixed with acrylic matte medium.*

Can I create an entire painting using ·nothing but glazes?

Multiple glazes can be superimposed to create complex colour variations. Remember to always work from light to dark, gradually building up the tone and colour until you arrive at the effect you want.

In what other ways can I use the glazing technique?

Glazes are often used over thickly impastoed paint and highly textured surfaces. The glazing gives a touch of delicate transparent colour to an otherwise heavy finish. If the glaze is gently wiped with a tissue or rag while the paint is still wet, the darkest colour will remain in the crevices, cracks and indented marks. This produces an effectively varied surface which – if the glaze colour is neutral and subdued enough – can often resemble that of an old oil painting or even a texture from nature. The bark of a tree or a mossy stone wall, for instance, could easily be depicted in this way.

Because acrylic colours retain a degree of transparency unless used very thickly, glazing, either selectively or over the whole surface, is a natural way of working. The method can be used for any subject but is especially effective for capturing the shimmer of water or the subtle colours of skin. It is also useful for toning down colours. When a picture is near completion, you may decide that one area is too bright. Rectify this by applying a grey or blue-grey glaze.

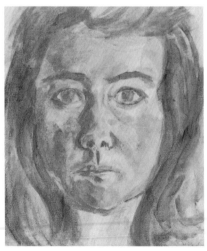

Above: *Successive layers of transparent paint were used for the face, with final touches of opaque pale pink laid over them on the nose, chin and brow.*

How do I get a nice, crisp, hard edge?

It is extremely difficult to paint a completely clean edge or a perfectly straight line – the brush almost always wobbles or the line meanders askew. It can help to hold your brush against a ruler, but it is better to use masking tape.

Masking is used by abstract painters to create crisp divisions between shapes, but it can be used in representational painting. If you are painting a white building using transparent techniques

you can use it to keep the paper clean for the white areas. Or if you are using opaque techniques to paint an interior with a window frame: you could use the tape to create a sharp division between this and the view outside.

Masking tape can be used on paper or canvas, providing it is not too heavily textured, in which case the tape will only adhere to the raised grain, allowing paint to slip beneath.

1. Thin red and yellow paint are streaked on to canvas board and allowed to dry before masking tape is applied.

2. The contrast between opaque, flatly applied paint and thinner, rougher applications will be a feature of the painting. The red is applied with a soft brush to even out the brush strokes.

3. Finally, the tape is peeled off carefully, leaving a crisp edge. It must be removed before the paint is dry, because dried acrylic forms a plastic skin, which will come away with the tape.

I love the look of heavy impasto in oils. Can I get that look with acrylics?

Yes, you can. Most acrylic paints are runnier than oils, so if you want to use heavy impastos for an entire painting you may need to thicken the paint with acrylic gel medium (see page 62). This is also an economy measure, because without it you might need a whole tube of paint for one area. If you are using white, or a colour with a high proportion of white, you are unlikely to need the medium. White is the thickest and most opaque of all the colours.

Can I use the impasto technique for an entire painting?

Impasto can be applied throughout a picture or in a single area. Thick paint, with highly visible brush marks, has a stronger presence than thin and will draw the eye, so artists often restrict it to areas they want to emphasize. You see this effect in oil portraits by Rembrandt (1606–1669), where thickly painted highlights on skin, clothes and jewellery stand out strongly against the thin paint used for dark areas and backgrounds. Adapt this idea to a landscape or still life, painting the background objects to create the illusion of space.

Can I use a palette knife to apply heavy impasto with acrylics?

Yes. If you enjoy applying paint thickly, try using a palette knife (see page 53). Knife painting is a form of impasto, but the effect is entirely different from that of brush impasto. The flat blade of the painting knife spreads out and squeezes the paint to produce a flat plane with a ridge where each stroke ends.

The ridges catch the light and cast tiny lines of shadow that you can use to define the edges and shapes in your subject. In a flower painting, for example, make separate, differently shaped knife marks for each petal or leaf and use the side or point of the knife for fine lines such as stalks.

Painting knives are also good for imitating textures. A rough stone wall, for example, could be rendered with a variety of knife strokes and later glazed over with other colours. Impasto is often combined with glazing techniques.

Can you give me an example of the impasto technique?

Yes, you may even want to paint along with this demo.

1. You may find yourself in trouble if you use thick paint from the start, because the colours will mix together. Block in the colours first with thinned paint, using a scrubbing motion to push them well into the surface.

2. Now begin to build up the sky with a thick, juicy mixture of white and phthalo blue. Try mixing the colour only partially on the palette, so that each brushstroke consists of streaks of two or more colours of paint.

3. Introduce some yellow into the sky and foreground to contrast with the blues. Do not worry if the colour looks too bright. Simply paint over it with another colour while it is still wet and the two will mix.

4. The thicker the paint, the longer it takes to dry. If the build-up of paint becomes too heavy for you to add colours without creating muddy mixtures, wipe some of the paint off with a rag before continuing.

Can a painting be created exclusively with a palette knife?

Certainly. A painting done entirely with palette knives (*see page 53*) has a lively surface effect and this can enhance the drama of the subject; it could be the perfect technique for a rocky landscape. But as with brush impasto, knife painting can be confined to selected areas, adding emphasis to tree trunks, for example.

1, 2. The first layer of paint is allowed to become touch dry before a second colour is laid on – a hairdryer is helpful here. Using a pointed knife, with the paint at tube consistency, the artist strokes the colour on to the surface. The first application of paint was pushed on to the surface, so it is relatively flat. The brown has been applied more lightly, creating thick ridges with distinct edges.

3. By twisting the knife slightly as he works, the artist allows the point to scratch into the paint, thus combining knife painting with a version of the sgraffito technique. This outline, as seen in the white highlights, enhances the overall edginess of the image.

4. White paint is now applied with the point of the knife to reinforce the linear element. These triangular knives are capable of surprisingly precise effects.

5. An ordinary straight-bladed palette knife is now used to remove small areas of the still-wet brown paint, suggesting the buttons on the jacket. Thickly applied paint dries slowly and can be manipulated on the surface for a considerable time.

6. Further knife strokes of both black and white paint were added in the final stages to complete the definition of the jacket.

ARTIST'S TIP

Special techniques like palette knife painting are lots of fun to try and can lead to some truly great works of art. But before you decide to paint with an unusual approach, carefully consider how compatible the visual qualities of the technique are with the visual qualities of the subject. This technique works here because the harsh, rough, angular palette knife strokes are evocative of the stiff, rugged qualities of denim.

Do you have any other ideas for applying heavy paint?

How about extruded paint? It is a fun way to finish off a painting with a lot of texture and personality. Follow the demo here to learn this unusual technique.

1. A design – based on a high-heeled boot – was worked out in a sketchbook and guidelines were penciled on the working surface, in this case a canvas board. The artist now begins to build up the picture with varying consistencies of paint.

2. By carrying out several stages of painting, the artist has given himself a foundation on which to begin the extruding. This method needs a decisive approach, since mistakes cannot be easily corrected.

3. Using a pastry bag improvised from tracing paper, the artist begins to outline the toe of the boot with black. He has bulked out the paint by mixing it with impasto medium.

4. Several pastry bags are needed to cater to different colours. A new one is now used to draw rows of carefully spaced diagonal lines, leaving the painted ovals uncovered.

5. The surface is then covered with a network of lines, circles and small dots. Care must be taken not to rest the hand on completed parts of the work, so the board is turned around from time to time.

6. At this stage, the picture is propped up at a distance to assess how much more work needs to be done. The boot clearly requires further attention, as it is less heavily textured than the background.

7. Using the pastry bag again, solid orange lines are made inside the red ones. The same orange was used first to outline the boot and then to strengthen the oval shapes in the background. The rest of the boot was built up with a finer network of lines overlaying the flatly painted colours.

ARTIST'S TIP

Whenever you're incorporating a lot of textures and patterns into a painting, as shown in this demonstration painting, it is a good idea to leave a few areas free of visual excitement. Look at the pink ovals in the background that are embellished with just a single line. These provide visual 'rest spots' for the viewer's eye, which makes the painting more enjoyable.

What other ideas do you have for adding texture with acrylics?

I can think of at least four more ways. The first is spattering. Spraying or flicking paint on to the picture surface is an excellent way of suggesting certain textures and may also be used to enliven an area of flat colour – perhaps in the background of a still life.

Watercolour landscape painters sometimes use spattered paint to convey the crumbly appearance of cliffs and sandy beaches, or spatter opaque white paint to describe the fine spray of a breaking wave. Spattering has obvious applications for transparent techniques, but there is no reason why it should not be adapted to opaque techniques. You might, for example, contrast an area of thinly spattered paint with one more evenly and heavily applied, or spatter a thin layer of colour over a thicker base.

Above: *The landscape in this picture has been blocked in simply, with little detail in the foreground, as this was built up afterward with spattered paint.*

How do I spatter the paint?

An old toothbrush is the implement most commonly used for spattering. You can also use a bristle brush, which makes a coarser spatter with larger drops of paint. Or, for a really fine spatter over a large area, use a plant sprayer or a spray diffuser of the type for use with fixative. In this case you must mask any areas that are to remain free of sprayed paint.

Whichever method you use, it is important to remember that spattered paint frequently lands in the wrong place – on your clothes, the floor and walls and your work table – so it is essential to protect all vulnerable surfaces. It is perhaps even more important to remember that acrylic paint is difficult or impossible to remove once dry.

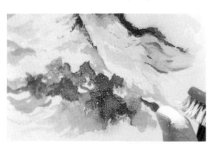

1. White spatter should be the final stage of a painting as working over it with more colours will stir up the paint, sacrificing the effect. The spatter paint needs to be mixed fairly thickly – too thin and it will sink into the thinner washes beneath it.

2. Use a thick acrylic paint because it is thicker and easier to control and so you can place the spattered paint precisely. Hold the toothbrush a few inches from the paper and run your thumb (or the handle of a paintbrush) quickly along the bristles.

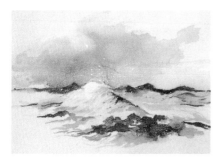

3. Do not overdo the spatter; it is most effective when kept light, as in this example.

> **ARTIST'S TIP**
>
> Always try the spatter mixture first. If it goes wrong, you can remove the paint, but this involves washing the entire area and beginning again.

Can you show me another texture-making technique?

This method – which can be carried out with an improvised scraper such as a plastic ruler or half an old credit card, or with one of the metal-bladed tools sold for removing wallpaper – is allied to knife painting, but produces flatter layers of paint that cover the painting surface more thinly.

It is ideal for layering techniques in which transparent paint is scraped over opaque or vice versa. You can also scrape lightly tinted acrylic medium over existing colour, producing a glazing effect that enriches the colour and gives it increased depth.

You can introduce variety by contrasting thinly scraped areas of paint with textured ones. Ridged patterns can be created with a notched plaster scraper. Or you could devise your own scraper by cutting notches in a piece of stiff board or plastic. The same method can be used for laying an under-texture modelling paste.

1. A plastic card is used to drag paint thinly across the surface. A metal paint scraper can also be used, but the flexibility of plastic makes it more sensitive. The surface is a canvas board laid flat on a table and secured with tape.

2. A darker colour is laid over the blue. Although the paint is at tube consistency, coverage is thin enough to reveal the colour beneath, giving an effect almost like that of glazing.

3. The greater rigidity of a paint scraper produces thicker, more irregular coverage, an effect that is now used to build up surface texture in places.

4. The card is pulled downward to create a veil of colour that accurately suggests the reflections. The pigment used in this case is relatively transparent.

5. The foliage on the far bank of the lake is built up more thickly. The paint is the same consistency as before, but instead of being dragged across the surface it is applied in a series of short, interrupted strokes.

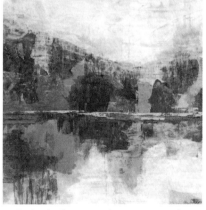

6. The finished painting shows a variety of effects that would be impossible to achieve with any conventional painting tool. Thin veils of colour contrast with discreet semi-impastos and lively edge qualities.

What else can you tell me about using acrylic modelling paste?

Acrylic modelling paste, which is specially made for underlying textures – though it can also be mixed with the paint – can be applied to the painting surface in any way you choose, but you must use it on a rigid surface; if applied to canvas it will crack. You can create rough, random textures by putting the paste on with a palette knife. You can comb it on to make straight or wavy lines, or dab it on with a rag or stiff brush. And you can make regular or scattered patterns by imprinting – spreading the area with modelling paste and pressing objects into it while it is still wet.

Overall imprints can be produced with crumpled foil or a stiff brush, or you could achieve recognisable patterns with a flat embossed item, such as a coin.

In general, texture should be used creatively rather than literally, so these methods are better suited to work with a decorative or semi-abstract quality than to representational painting. Trying to mimic texture in a visual subject does not always work well, though you might use texturing in an urban scene, for example, to suggest rough stone walls or brickwork.

Experimentation is part of learning to paint and it is always worth trying different methods of creating texture. Make up a series of samples similar to the ones shown here.

Above: *Aluminium foil. A piece of crumpled foil pressed into wet texture paste (above) produces a coarse, stippled surface.*

Above: *Paint mixed with sand. Using a dull red or grey, this grainy texture could imitate old brick or stonework.*

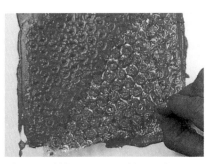

Above: *Bubblewrap pressed into paint creates an even texture, which could bring interest into the background of a still life.*

Above: *Fabric, such as terrycloth, pressed into thick paint gives a less obtrusive texture. This is ideal for actual fabric in a portrait.*

Above: *Combing or scratching into paint can create a variety of effects. These could suggest trees or grasses blown in the wind.*

Above: *Crushed eggshells stuck down with gloss medium and painted over. Use for the foreground of a stony beach.*

Above: *Coins pressed into modelling paste and painted with transparent paint. It could be used to contrast with flatter paint.*

And what's the fourth texture technique you mentioned?

Sgraffito (from the Italian *graffiare*, to scratch) means scoring into the paint to reveal either the white of the canvas or board, or another colour below. Sgraffito is another technique that has been borrowed from oil painting.

1. Paint can be scratched to reveal the white surface below, but in this case the artist intends to scratch back to another colour. She therefore lays a red ground all over the canvas board before painting the fruit and basket.

2. When painting the blue background, she deliberately leaves a little of the red showing between the brush strokes. She will reinforce the colour contrast by scratching into the blue later.

3. She has used retarding medium, so the paint is still sufficiently wet to be removed with the point of a knife. If it becomes too dry, harder pressure has to be applied and this can remove the first layer of paint as well as the second.

4. Both the point and the serrated edge of the knife are used to create a variety of lines in the blue background.

5. With the fruit now painted, the point of the knife was used to pick out dots of red on the lemon. A light glaze was laid to create the shadow on the left side of the basket and now the pattern is built up with further knife scratching.

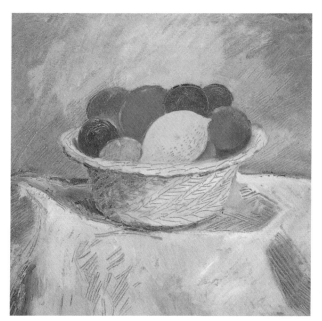

6. The effect of the painting relies partly on the colour scheme, which has been well chosen to provide blue/red contrasts in each area. The red sgraffito into blue balances the bright colours of the fruit and gives extra impact to the scratched lines.

What if I want a very subtle texture?

You could always try hatching, a painting technique that has been adapted from pen-and-ink application methods. Hatching consists of criss-crossing hundreds of small strokes, one over another to produce a rich, variegated effect. The more dense the network of strokes, the more dense the colour.

Left: *Hatching using ink. By varying the density of the lines, a wide variety of shades is achieved. Freely drawn lines look more lively than perfectly straight, mechanical ones.*

Below: *An old, splayed brush was used to create this slightly rough, hatched texture in acrylic. The underlying colour glows through overpainting to great effect.*

Can you recommend a technique for starting a painting? Do you suggest starting with a drawing?

It is not essential to draw before you paint. Some artists are content with a few pencil lines or marks drawn with a brush to give the main placings of the subject. However, unless you are very experienced and know exactly how you are going to organise your composition, it is wise to draw first, particularly if your subject is at all complicated or involves hard-to-draw elements such as figures.

If you are using opaque techniques, the paint will completely cover your drawing, so you can draw in whatever medium you like – pencil, charcoal, or a brush and thinned paint. It may be best to avoid charcoal if you intend to start with pale colours, as it can muddy them slightly. Some artists like this effect, while others prefer to keep the colours pure from the outset.

Transparent techniques need more planning. You can't paint over mistakes without losing the transparency, so you must have a good drawing. Heavy lines, though, may show through the washes, particularly in very light areas. This may not matter because pencil lines can combine well with watercolour effects, but it could be crucial. For example, if you are painting a seascape and have drawn a horizon line which you later decide to lower, you will have a pencil

line showing through an area of sky. You can't erase it, as the plastic coat formed by the paint will have sealed it in place. So keep the lines as light as possible, avoid shading and do not start to paint until you are sure the drawing is correct.

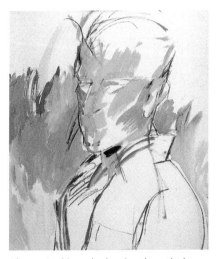

Above: *In this underdrawing the artist has used charcoal and cerulean blue to make a rapid sketch of her subject. The background is indicated in black and white and the flesh tones in yellow ochre and yellow. The drawing is then developed in cadmium yellow and bright orange. These vivid colours are used to describe the figure and develop the form.*

Can you do a block-in with acrylics?

Yes, fast-drying acrylic paint is ideal for creating a block-in. This method is only suited to studio work, but for any large or complex composition, such as a figure group or highly organised still life, it can be more useful than underdrawing (*see page 133*) because it allows you to work out the main light and dark areas.

Sometimes areas of the underpainting are allowed to show through in the finished work, so the colour must be chosen carefully, as when you are using a coloured ground. You can make a monochrome underpainting in shades of one colour to contrast or blend with the overall colour scheme, or use one in shades of grey. However, in the latter case, if you intend to apply the colours thinly, you run the risk of losing colour purity. However, this could work very well for a painting with a low-key colour scheme.

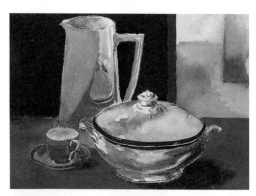

Again, some areas are left white or pale grey to avoid muddying the translucent, watercolour-like washes. The dark grey used for the background gives strength to the red-brown laid on top.

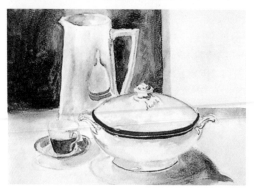

A grey underpainting, made by thinning black paint with varying amounts of water, establishes the tonal structure of the composition.

Do you recommend painting on a white ground or a toned ground?

Canvasses and boards sold for acrylic painting are usually white, but you may find it helpful to lay on a tint before starting to paint.

Some artists like a white surface, particularly if they intend to paint thinly, because light reflected back through the paint gives the work a luminous quality. Others find a white surface disturbing, as it makes it difficult to judge the relative lightness or darkness of the previous colours.

There are no true whites in nature, so the canvas or board provides an artificial standard. Virtually any colour you put on will look dark in contrast and you may find you are working in too light a 'key'. If you tint the board with a mid-shade, you can work up to the lightest colours and down to the darks.

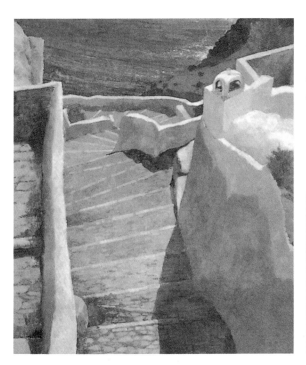

Left: *A traditional ochre ground helps to warm up the whites and contrasts well with the blue of the sea.*

ARTIST'S TIP

Most people would list the Impressionists as some of their favourite artists. How did Monet, Pissarro and their friends get that buoyant sense of sunshine? Painting on a white ground was their secret to capturing light.

What's the best way to tone a ground for an acrylic painting?

Laying a ground colour is simplicity itself. All you do is paint a colour over the surface using a broad brush. If you prefer to use the paint in a series of thin layers, either on paper or canvas, a transparent colour might be best, using well-diluted paint. You can also use thick paint, vigorously working it into the surface so that it provides a slightly rough texture.

Whatever your subject, you can use a coloured ground as a starting point. First decide what the overall colour scheme is to be, because the ground will influence the applied colours.

Above: *A rag spreads the paint thinly so that a strong colour, such as the red used here, becomes paler.*

Above: *A broad brush, used with medium-consistency paint, makes a series of striated marks that provide added interest.*

Left: *An uneven watercolour-type wash also makes a good ground for many different painting techniques.*

What colour should I choose to tone the ground?

Usually a neutral colour is chosen, such as grey, grey-blue, or an ochre-brown. Some artists always use the same colour; others choose a different one for each painting.

The colour can contrast with the overall colour key of the painting; for example, a warm brown or yellow for a snow-scene with a predominance of cool blues and greys. Alternatively, you can use a ground colour that blends in with the applied colours.

Artists who work on coloured grounds often leave small patches of the ground uncovered, whether it is in a toning or a contrasting colour. This helps to give the picture unity, as repeating colours from one area to another ties the separate elements together.

Above: *A medium-blue ground, on watercolour paper, was used for a landscape using harmonies of blue and yellow.*

Above: *A cadmium red ground was used for this painting of trees.*

ARTIST'S TIP

If you like a lot of drama in your paintings, you may want to consider toning your ground in the complement of the predominant colour of your subject. For example, under a landscape full of greens, you could use a medium-red ground. For a seascape, use orange. Hints of the complementary colour will peek through the finished painting and give it an extra punch.

Can you give me an example of using some of these techniques?

Great idea! Let's study how two artists used some of these techniques to paint the same subject, using the same palette.

The divergence in technique is apparent from a quick glance at the finished paintings opposite. The pictures are revealing in other ways, too. No two artists will approach a subject in an identical way, even when the same basic technique is adopted. There will be stylistic differences, as there are here, with artist one applying sweeping strokes and softer blends of colour and artist two using shorter, separate brushmarks. There will also be compositional variations, with each artist choosing a different viewpoint and arrangement of elements on the surface. A comparison of the photograph with the paintings shows how and why the artists made their particular choices.

CHOICE OF VIEWPOINT
The frontal view seen in this photograph does not provide an ideal composition. The glass and bottle are thrust together in an uneasy way and the bowl of fruit does not have enough prominence. Artist one moved in to reduce the background and by taking a position to the right of the

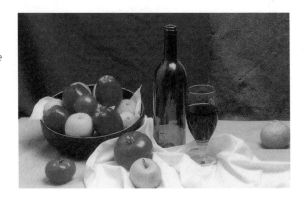

group stressed the overlapping forms and the strong diagonal made by the left-hand edge of the tablecloth. Artist two also moved in more closely to give greater emphasis to the fruit and painted from slightly left. This viewpoint separated the large tomato and the apple, increased the gap between the bottle and the glass and placed them against the green, not the red, part of the background. Whatever your subject, look at it from different angles to decide on the viewpoint that you feel will make the best picture.

ARTIST ONE

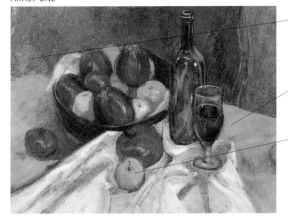

A little of the green ground colour can be seen here, only partially covered by later glazes of purple and mauve.

The glazing method gives a smooth effect, with colours gently blending into one another.

Successive layers of colour were glazed over one another, starting with a green ground and a light purple glaze and working up to vivid reds and greens.

ARTIST TWO

An exciting effect is produced by the broken colour and lively brushwork, with separate brushmarks of red, orange and mauve following different directions.

The use of large, square-ended bristle brushes gives a distinctive style. The yellow band of highlight was dry-brushed over the greens.

To suggest the texture of the cloth, a dry-brushing method was adopted, with thick white paint dragged over earlier applications of colour.

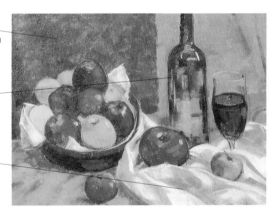

DIFFERENT PAINTING METHODS

The two pictures show very different uses of acrylic. In the painting above, the artist created an oil-painterly effect, applying thick, opaque paint, with areas of broken colour (see page 110) and dry brushing (see page 106). In contrast, the colours in the painting at the top of the page were built up gradually by a series of overlaid transparent glazes (see page 116), using paint mixed with acrylic medium. Both are on canvas and rich in colour, but the overall tonality is darker in the top painting due to the middle-toned coloured ground (see page 136).

8
COMBINING ACRYLICS
WITH OTHER MEDIA

Can acrylics be combined with other media?

Indeed, yes! Acrylic lends itself to mixed-media work more than any other artists' medium (see page 14). Apart from being able to combine with different substances and materials to get a whole range of textures and surface patterns (see page 128), it can also be used with pastel (see page 150), ink (see page 146), watercolour (see page 155) and gouache (see page 154) and with many drawing materials such as pencil (see page 152), crayon, Conté crayon, chalk and charcoal.

Illustrators often combine acrylic with another medium, sometimes painting a realistic image over a random background of tissue paper collage (see opposite), sometimes using the acrylic to block in lively areas of local colour and then drawing a detailed image over this with pencil, charcoal, pastel, or pen and ink. Combinations such as these keep a picture alive and interesting and often reproduce better than an illustration done in opaque paint only.

Often regarded as a modern rival to oil paint, acrylic can also be extremely helpful to oil painters, complementing rather than competing with the oil colours (see page 156). Because oil paint can be safely applied to an acrylic surface, it is possible to use acrylic for the first stages of a painting – the initial 'blocking-in' of the main areas – and to continue in oil (see page 134).

This can save a lot of time, because normally an artist has to wait until the blocking-in is dry enough to be worked over. With oil paint this can be several days, but if the first basic underpainting is done in acrylic, the paint is normally dry enough to be painted over almost immediately. The artist can then use oils for the final stage, when the slow-drying colours can be worked and moved around over a longer period of time, to make final adjustments to tone, colour and detail.

It is important to remember that acrylic cannot be used over oil paint in the same way. Even if the paint appears to be going on normally, an oily or greasy surface will eventually repel acrylic and your painting will be short-lived.

Sculptors and craftsmen are also discovering the advantages of acrylic and acrylic mediums. It is the natural colour for much of the plastic and fibreglass materials now used in three-dimensional art, although it can be used equally well on metal, wood and masonry. It is especially useful if the work is to go outdoors, when a weatherproof paint is essential.

Above: View Over Ullswater, *Hazel Harrison. Acrylic was used only for the problem areas of foreground and tree, both of which lacked definition. The effect is very similar to that of watercolour thickened with white gouache, but the artist is accustomed to working in acrylic and finds it easier to handle.*

Can you give me a simple example of acrylic combined with some other medium?

Let's start with line and wash, a traditional watercolour technique that dates back to the 17th century, before watercolour had really come into its own as a painting medium. At that time, watercolour was used mainly to lay flat washes of colour over pen drawings.

Since that time, however, artists have used line and wash in more inventive and expressive ways. The problem with the traditional method of making the drawing first and adding the colour is that the two mediums can fail to gel and it is difficult to avoid the effect of a coloured-in drawing. It is usually better to develop the line and colour simultaneously, so that you are constantly aware of the relationship you are creating between the two.

The kind of pen you choose will depend on the effect you want. Some line and wash drawings are fragile (the technique is much used for flower studies) and others are bold. Experiment with different pens, from fine nibs to fibre- and felt-tip pens or even ballpoints – an underrated drawing implement. You might also try using water-soluble ink, which will spread when wet colour is laid on top, creating soft, diffused effects.

The paint you use for the washes should be kept thin, or it may detract from the effect of the drawing, so it is best to choose transparent pigments. The paint can be thinned with water alone, or with a mixture of water and medium (*see pages 58-61*).

1. Using a fine-tipped drawing pen and working on smooth drawing paper, the artist draws the shapes of the flowers, keeping the lines light.

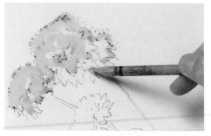

2. With the paint thinned to watercolour consistency, the artist touches in colour with the tip of a Chinese brush. Because the ink is water-soluble, the wet paint spreads it slightly, giving a soft effect.

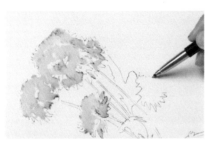

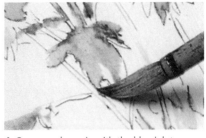

3. Further details are added with the pen, again using a light touch to avoid the effect of a filled-in drawing.

4. Green washes mix with the blue ink to create an impression of delicate shading on the leaves.

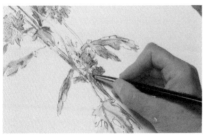

5. The pen is now used in a more positive way to draw into the leaves with diagonal strokes of hatching and cross-hatching.

6. A light wash is laid over the background and taken carefully around the edges of the flowers.

7. To provide a context for the flowers as well as some colour contrast, the background wash was extended and the top of the vase sketched in lightly in pen.

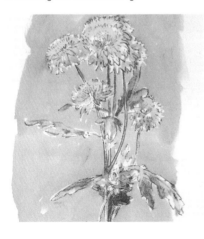

ARTIST'S TIP

A single object placed on a simple background can be beautiful. Just remember to place the object on the surface so that your 'negative shapes,' meaning the shapes surrounding the object that divide the background, are interesting.

Do I have to apply the ink with a pen?

No, that's a good point. You can also apply both the inks and the acrylics with a brush.

These two media are natural partners and are particularly suitable for transparent techniques on paper. Coloured drawing inks (some of which are water-soluble and others shellac- or acrylic-based) are transparent and have considerable depth of colour, so they can be used to reinforce washes of transparent acrylic colour.

Black drawing inks (sometimes called Indian inks) are thicker and more opaque. These can be used in line and wash techniques with thin acrylic, or painted on with a brush either over acrylic colours or side by side with them. Brush drawing in black ink makes a very positive statement, so this approach is best suited to bold work; use with strong areas of colour complementing the dense blacks.

You can also exploit the differences between media by using the acrylics opaquely in combination with transparent coloured inks. As in all mixed-media work, there is no fixed way of working; experiment until you find the method that works best for you.

1. Because the subject is a complex one, the artist made an underdrawing before putting on the colour. She uses a combination of black ink and paint, pushing the paint around on the surface with her fingers. The ink she has chosen is an acrylic-based one called 'liquid acrylic,' which is made in a range of colours.

2. Yellow ink is now applied directly from the dropper. A brush or pen can also be used, but the dropper gives a free, impressionistic effect similar to this artist's style.

3. She wants a loose effect in the sky also, so she uses a slightly dampened rag to spread marks made with water-soluble crayon. The smoothness of the paper makes it easier to move colour around in this way.

4. In this detail you can see the different surface textures achieved by combining inks with thicker applications of paint. Ink has been used for the purple boat and the black one in the foreground, with brushstrokes of paint overlaying the ink in places.

5. Again using ink straight from the dropper, a small, irregularly shaped mark is made to suggest a boat in the background of the picture and echo the reds of the foreground boats.

6. Throughout, there has been no attempt at literal description. None of the boats or other features have been dealt with in detail, but the painting successfully conveys the atmosphere of a harbour, with all its colour and movement.

Could I use charcoal to make a line-and-wash painting with acrylics?

Yes, you can combine thin washes of acrylics with any drawing medium you would normally use on paper.

Charcoal is in itself a versatile medium, capable of producing both fine lines and rich areas of colour. By combining it with acrylic you can achieve a wide range of exciting effects.

There are many different ways of working. For a portrait you might map out the composition with charcoal, using it also to block in the background, then paint the face and head before working more charcoal into this. For a landscape you might begin with loose overall washes of colour and then use charcoal to define details and build up areas of darker hue.

In any mixed-media work it is important to think in terms of a marriage – the media should blend together while retaining their separate identities. Charcoal has a matte surface, so unless you have a reason for aiming at textural contrast, it is probably best to keep the paint matte also, by thinning it with water rather than with a medium.

1. The artist begins with loose washes of colour, keeping the paint fairly thin so that he can draw over it with charcoal. He is working on watercolour paper.

2. A stick of thick charcoal is used to draw over and into the paint, gradually building up the definition.

3. When a drawing medium is used with paint, both line and colour must be developed at the same time. Paint has now been laid around and between the charcoal lines on the patterned fabric.

4. With the paint still wet, the whole left side of the picture has been sprayed with water, using a mouth diffuser. A spray bottle filled with water can do the same job.

5. In this detail you can see the effect of the water spray, which has created a soft, granular texture. The paper was allowed to dry before the artist continued working into the paint with charcoal.

6. When the charcoal drawing on the fabric is complete, a small bristle brush is used to dab in touches of magenta. This brilliant colour provides a balance for the hot colour of the suitcase, which might have been too dominant.

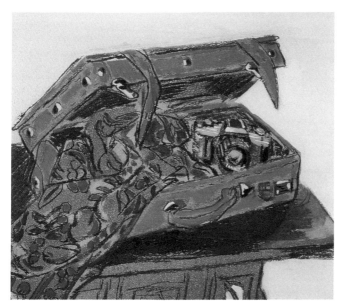

7. Finishing touches were the addition of highlights on the metal fittings of the suitcase and some further charcoal drawing on the table.

Can I combine acrylics with pastel?

Like many mixed-media techniques, a combination of pastel and acrylic can either exploit the differences between the component media or unite them into a homogeneous whole.

An example of the latter approach is the technique employed by some pastel artists of making an acrylic underpainting. Sometimes the whole of this is worked over in pastel and sometimes parts are left as they are. Because it is difficult to cover an entire surface with pastel strokes, this practice avoids the possibly distracting effect of white paper showing where coverage of pastel is light. It is also a means of achieving broken colour and colour

contrasts – small areas of, say, a blue underpainting showing through an application of red or purple pastel can create wonderfully vibrant effects.

Sharper media contrasts can be achieved by starting with acrylic thinned to a watercolour consistency and drawing on top with pastel or oil pastel. In such cases it is probably best to relegate the pastel to a secondary role, using it perhaps only to define an area of pattern or enhance some detail.

However, the two media can also be used hand in hand. Both acrylic paint and acrylic matte or gloss mediums are excellent fixatives for pastel, so you can build up a painting by a layering method: applying some paint and pastel, then covering the pastel with medium or paint and laying on more. Wet paint or medium can cause the pastel colour to spread slightly, but this gives a watercolour effect at the edge of each stroke, which can be very attractive.

Above: Backs of Buildings, St Mary's Road, Southampton (England), *Mike Bernard. Collage is a technique particularly well suited to architectural subjects and here it has been skillfully used, in conjunction with acrylic, inks and pastel. The varieties of paper used for collaging give an impression of textures without attempting to imitate reality. The printed paper in the right-hand area of the foreground has been placed upside down to prevent it from being overly obtrusive.*

1. The composition was first sketched out in soft pastel, using a combination of linear strokes and side strokes – those made with the side of a short length of pastel. A transparent wash of water-thinned paint is brushed lightly over the pastel. Because the paint forms a plastic skin, it fixes the pastel, allowing the artist to work on top with no risk of smudging.

2. Further washes are now laid over the background area. The artist develops the two media together, so that the painting has a unity of technique from the outset.

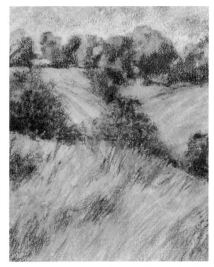

3. The artist continues to build up the painting with both paint and pastel. Because the watercolour paper has a slightly rough surface, it breaks up the pastel marks to provide a broken colour effect.

4. The finished painting is a good example of a successful marriage of media. Although there is a contrast of textures within it, no one area can be singled out as being either paint or pastel.

How about pencil?

Another great combination! Pencil can be used under washes of acrylic colour or on top of any paint that is transparent or opaque (see opaque techniques and transparent techniques *pages 90 and 92*).

If you want a strong contrast between paint and line, try using pencil for one part of an image and paint for others. This device is sometimes used by illustrators, who deliberately exploit media contrasts and juxtapose areas of colour and monochrome to achieve an impact from the unexpected.

However, you need sure intentions and a degree of skill for this kind of work, so it is probably best initially to employ the two media in a more integrated way. If you are using transparent techniques, one of the problems inherent in acrylics can be turned to advantage. For water-colours and for watercolour effects in

acrylic you need a good underdrawing. In actual watercolour work, this can be erased after the first washes are in place, but this is not possible with acrylic, which acts as a fixative on the drawing. So try making the drawing a part of the picture from the start, laying colours over and around pencil lines and adding pencil as the picture takes shape.

Opaque paint will, of course, obscure your original drawing, but you can still use pencil on top. How much you use and in what way depends on the effect you want: You might reserve the pencil drawing for small areas of detail or pattern, or for parts of the picture that are easier to draw than to paint, such as flowers, stems, the edges of leaves, or facial features. A soft pencil is also excellent for shading to model forms, which can be tricky in acrylic because of the fast drying time.

1. The shape of the building is blocked in with thin paint. A smooth-surfaced paper is used. Less absorbent than watercolour paper, it does not even out the paint as much, allowing the brushstrokes to play a part in the composition.

2. The artist begins to draw into the paint as soon as it is dry, using a graphite stick – a pencil without the usual wooden casing. He then applies a loose blue wash for the sky and defines the details at the top of the tower.

3. The shapes of the palm leaves have been built up with a combination of brush strokes and graphite drawing. Now a small brush is used to pick out some highlights with pale blue-grey paint.

4. Touches of drawing suggest the rough stonework and the graphite stick comes into play again for the shadows below the small outgrowths of shrub.

5. In the final stages, more graphite drawing was done on the building, giving an accurate impression of the textures of the old plaster and stonework. The drawing, the light colours and the free brushwork in the sky all contribute to the atmosphere.

ARTIST'S TIP

Keep in mind that there are many types of pencils you could use to define and embellish an acrylic painting. In addition to hard and soft lead pencils, you could also use a charcoal pencil or even a watercolour pencil, which you could then soften with a few strokes of water.

Is it okay to combine acrylics with some other paint?

The artist used gouache as well as acrylic in this picture. These two types of paint are compatible. The difference between them is that when acrylic is laid down it cannot be dissolved (unlike gouache and watercolour, which can be manipulated with water even after they have dried). Acrylic, therefore, is very useful for the monochrome underpainting technique. It dries as quickly as gouache and gives a stable undercoat on which the colour can be applied. The artist can manipulate the gouache with water, moving it around and blending it, but the acrylic beneath will not be affected. Thus the artist can work in genuine stages. If the acrylic undercoating were to dissolve, the white and neutral colour would soon make the top colour very grey. This method keeps it pure.

Above: *In this painting the artist takes advantage of the quick-drying properties of acrylics by using them for the tonal underpainting before applying the top colour in gouache. Acrylic does not dissolve once dry and therefore provides a stable base for the water-soluble gouache. The acrylic underpainting, built up in thin layers of raw umber, will not mix with the wet gouache when it is applied – this would cause the final colours to turn muddy.*

Above: *Contrasting tones are introduced into the underpainting, above. Deep, opaque colour indicates the dark shadows behind the model and white acrylic is introduced into the lighter areas. This underlayer of bright white will produce luminous, semi-transparent colours when thin layers of gouache are applied over it.*

What other painting medium works well with acrylics?

Watercolour would be my other choice. We have already seen some of the advantages and disadvantages of using acrylic as a substitute for watercolour. It can also be used hand-in-hand with watercolour, which is perhaps a more satisfactory way of working, as it allows you to use both to the best advantage.

Watercolour painters often use a touch of 'body colour' (opaque paint) here and there, perhaps to sharpen a foreground, to add white highlights, or simply to correct a mistake. Usually gouache paint is used, or Chinese white mixed with watercolour, but acrylic is a better choice than either of these, as it does not give such a matte, dead surface.

Paintings that are officially classified as watercolour frequently include acrylic and if the acrylic is used skillfully it is often impossible to tell which is which. The trick is to reserve the pure watercolour for any areas that need its particular translucent quality and to use the acrylic fairly thinly – it should be capable of covering colours below but should not stand out from the surface. In a landscape with grass and trees in the foreground, for example, you would use pure watercolour for the sky and the far distance and acrylic – either on its own or over watercolour washes – for the foreground and perhaps any

areas of texture in the middle distance, such as a wall or group of houses.

Because the slightly thicker paint has more physical presence than the thin watercolour, it will tend to come forward to the front of the picture. This allows you not only to describe foreground detail and texture (always difficult in watercolour) but also to accentuate the sense of space.

Above: Waterlilies, *Norma Jamieson RBA, ROI. Acrylics and watercolour on coarse drawing paper. The artist works partly from life and partly from transparencies and says that the former gives the necessary element of spontaneity to her work while the photographic studies provide the equally necessary time for consideration. For specific flower forms, she takes numerous slides, from different angles and positions and in close-up, using the camera like a sketchbook and then distilling what interests her most when she begins to paint.*

So I shouldn't attempt to combine acrylics with oils?

I wouldn't recommend attempting to combine the two types of paints, but there is something called 'wax resist.'

Wax resist is a technique that relies on the incompatibility of oil and water. Like masking, it blocks the paint from certain areas of the picture, but the effects it creates are quite different.

The basic method is simplicity itself: A candle or any waxy crayon is used to scribble over clean paper and a wash of water-thinned acrylic is laid on top. The paint slides off the waxed areas, leaving a slightly speckled area of white.

Watercolour painters often use the technique to suggest clouds, waves, or ripples in water, or the textures of cliffs and stone walls, but it has many other possibilities and is good for mixed-media work, such as ink and acrylic.

You are not limited to a white candle or crayon; you can use coloured wax-oil pastels, or the newer oil bars, which are excellent for wax resist, making a drawing in several colours which is then overlaid with a contrasting colour of paint. You can even build up a whole picture by means of a layering technique, scraping or scratching into the wax before putting on more paint (or perhaps ink), then adding further wax and so on. If you try this, work on tough paper or you may damage the surface. And remember to keep the paint well-thinned – if it is too opaque it may cover the wax completely.

1. Watercolour paper was tinted with coloured gesso, which provides a slight texture and reduces the flare of white paper. A pencil drawing was then made as a guide and wax applied lightly to the top of the cabbage.

2. The thin, watered acrylic paint slides off the wax. Thick paint is less suitable for this method, as the tough plastic skin formed by opaque acrylic paint can cover the wax completely.

3. Further drawing is done with the sharpened end of a household candle. The coloured ground helps the artist to see where she is putting the wax; however, this can be a rather hit-and-miss affair on white paper.

4. Another application of paint builds up the texture of the painting, with the paint creating a series of tiny dots, blobs and dribbles as it slips off the wax and settles in the non-waxed areas where it dries.

5. To create more precise, linear effects, the point of a knife is used to scratch away the small drops of paint that have settled on top of the wax. The artist has turned the board around to gain access to this area of the picture.

6. A white oil bar is now used to draw over the paint, giving more definition to the cabbage leaf, which was previously rather amorphous. The bar has also been used to reinforce the drawing in the centre of the cabbage.

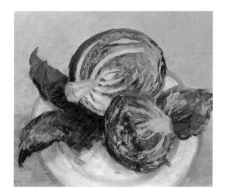

7. The finished picture shows a lively combination of pattern and texture. The oil-paint bar, which has been used on the cabbage and the plate, gives a painterly quality.

ARTIST'S TIP

Like oil paints, oil sticks are incompatible with acrylic paints unless you are using them expressly for the wax resist technique demonstrated here.

Can I use acrylics in a collage?

The word collage comes from the French *coller*, to glue or paste and it describes a picture made by gluing pieces of paper, fabric, photographs, newspaper cuttings – or anything you like – on to a working surface. These can be combined with paint, or the whole composition can consist of glued-on fragments.

Acrylic is the perfect medium for collage work. Both paints and mediums have powerful adhesive properties and are capable of securing quite heavy objects to the picture surface. If you use texture paste (as in the picture below) and press objects into it – like shells, scraps of tree bark, grasses, or even keys, beads, or small piece of jewellery – you can create three-dimensional effects akin to relief sculpture. In such cases, a final coat of colourless medium should be used to seal and protect the work.

Alternatively, you can use paint and paper alone, placing the emphasis on two-dimensional pattern and the juxtaposition of colours. Some artists employ a layering technique, gluing on fragments of coloured paper with acrylic medium, covering these with paint and perhaps more medium, then more paper and paint. Others will begin a painting in the normal way and then collage certain areas.

A collage can be as simple or complex as you like; it can be abstract or semi-abstract, realistic or purely decorative. Collage is essentially an experimental technique, so there are no hard and fast rules. However, if you are trying the three-dimensional approach and using paint and medium thickly, work on a rigid support such as a plywood panel, as otherwise the dried paint may crack.

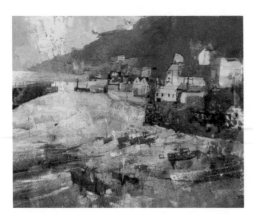

Left: View of Mousehole, *Mike Bernard. Although this work on paper contains elements of collage, the artist prefers to describe it as a mixed-media painting, because he does not rely on collage alone to produce areas of texture. He has combined collage with pastel, paint and coloured inks, applied with a number of different tools, such as rollers, sponges, toothbrushes, pieces of cardboard and palette knives.*

Left: Winter Lake, *Jill Confavreux. This painting evolved as part of a series on the theme of frozen ground. The working surface was a medium watercolour paper, on to which the artist glued acid-free tissue paper with gloss medium. This texture formed the ground over which she painted and poured acrylic glazes, followed by a light scumble of gold and silver oil pastels. These acted as a resist for further applications of paint, creating some lovely effects.*

Left: *This detail shows the variety of textural and colour effects produced by this layering method. The final stage was to apply a glaze, cover the surface with plastic wrap and peel it off when the glaze was dry.*

CHAPTER

9
LEARNING PICTURE-
MAKING BASICS

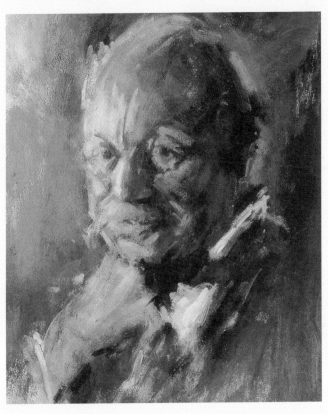

I'm confused and intimidated by the word 'composition'. What does it mean?

Many people struggle with the idea of composition, but it is actually much more simple than you might think. However well you paint, you must also pay attention to the composition of your picture. A good painting is an interpretation of something seen, rather than a faithful copy. Nature provides the ingredients, but you decide how you want to place them on the canvas and whether you will emphasise some features more than others.

If your subject is a still life (*see page 216*) you will have chosen the objects and arranged them in a way that pleases you, but for outdoor subjects you make your selection at the painting stage. You do not need to include everything you see, nor do you need to paint everything in equal detail. If a new fence or a utility pole detracts from a landscape scene, leave it out, or play it down by treating it with the minimum of detail.

Do you have any rules for composition?

There are no unbreakable rules about composition, but there are some guidelines. Aim for a good balance of shapes, colours and tones, so that there is interest in every part of the picture. Try to set up visual links that bind all the

elements together into a unified whole. You can do this through colour, but you can also arrange the shapes so that they establish harmonious visual relationships. A dark clump of trees in the middle distance might be balanced by a shrub nearer the front of the picture, creating a link between the two.

Avoid making your composition too symmetrical. Dividing the picture into equal areas of sky and land, for example, produces a disjointed effect. Nor is it wise to place some dominant feature directly in the centre, because this makes a dull and static composition.

Above: *A still life of objects silhouetted against the light could be a good starting point for a semi-abstract treatment, as backlighting cuts out much of the detail and allows you to see shape rather than form. Here the composition is seen entirely as an arrangement of shapes.*

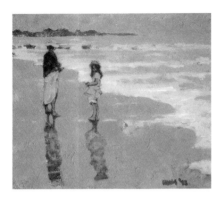

Left: *The figures and the shadows make a leaning vertical shape, intersecting the curves and horizontals of the water and thrusting upward to the smaller curves of the cliffs.*

Above: Two on the Wet Sand, *W. Joe Innis. This composition also makes use of the interplay of shapes, with the scalloped curves of the water contrasted with horizontals and near-verticals (see above right). But what is more immediately noticeable is the restricted colour scheme, which unites all areas of the picture. To avoid possible monotony of colour, the artist worked on a pinkish ground, allowing patches of this warm colour to show through the cool blues and blue-greens and form a link with the skin tones of the figures.*

Left: *This shows how the picture is divided into a series of large and smaller shapes and three basic tones: light, middle and dark.*

Above: North Hill, Trees, *Paul Powis. Reduction to essentials. A composition does not need to be complex to be successful. This painting derives its impact from the way the artist reduced the scene to its bare bones, basing his composition on strong contrasts of tone and on the interplay of simple shapes. The three key shapes are those of the sky and the two hills, cleft by the path. The smaller shapes of the dark trees echo those of the hills and form a link between them and the sky, which was painted flatly so that it reads as a shape in its own right. The only touch of detail is the suggestion of grass texture in the foreground.*

What's the first thing I should do when I begin to compose a painting?

Painting is a continual process of making decisions. Your first decisions concern not only what to paint but from what viewpoint. It is surprising how radically a change of viewpoint can alter a subject, even if all you do is to raise or lower your own eye level. A low viewpoint makes the foreground more dominant; in fact, a tall foreground feature can block your view of the distance. In still life, looking down on the subject can provide a better composition than viewing it at eye level. A high viewpoint organises the elements into a pattern.

The angle of viewing has a direct effect on how you perceive the spatial relationships of objects. Trees in a landscape may overlap and be difficult to read from one angle, but if you move to one side they will separate out.

A viewfinder (*see page 166*) will help you to decide which part of the subject to focus on and how much to include. For example, do you want to bring a group of trees in the middle distance nearer by reducing the foreground? If you have no viewfinder, use your hands to make a rough rectangle.

Can you explain a little more about symmetry and balance?

One time-honoured method of working out composition is to use the Golden Section. This divides a rectangular shape into what are considered to be the most harmonious and satisfying proportions.

The concept has been recognised for at least 2,000 years and holds that the most harmonious relationship between unequal parts of a rectangle is achieved if the smaller section is in the same proportion to the larger section as the larger section is to the whole. It is worked out geometrically, although most artists prefer their decisions to be visual rather than mathematical.

Above: *To find the Golden Section, draw a square ABCD. Divide DC equally at E. Taking E as the centre, construct an arc through B. Extend DC to meet the arc at G. Construct rectangle ADGF.*

A lower viewpoint would have reduced the amount of sea visible and the heads of the figures would have jutted into the sky, making the composition less satisfactory.

The verticals of the reflections, created with light downward brushstrokes, counterpoint the dominant horizontals.

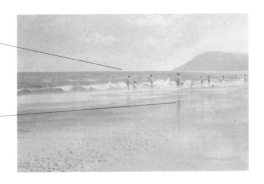

Above Cornish Summer, *Bart O'Farel. Emphasising the foreground. The artist decided to place the figures at a distance, choosing a viewpoint that allowed him to make the most of the glistening expanse of wet sand in the foreground. He worked from a standing position, with his head at roughly the same level as the figures.*

Left: A Moment in the Sun, *William Roberts. The high viewpoint chosen for this still life emphasises the flat-pattern element and the contrast of shapes. Notice how the shadows beneath, beside and within the objects are treated as shapes in their own right and stressed by sharp divisions between light and middle tones, so that they contribute to the overall pattern.*

The shadows and light areas create their own pattern.

Where can I get a viewfinder?

You can purchase a ready-made
viewfinder from any art supplier or
you can make one.

Right: *An adjustable viewfinder is made by
cutting two L shapes of cardboard, which
you can slide over one another, turning a
horizontal rectangle into an upright one or a
square. The cardboard should be black or
grey rather than white.*

What's the next step after choosing my viewpoint?

When you have chosen your viewpoint,
select the format for your painting. The
majority of landscapes have a horizontal
emphasis, but for certain subjects, such
as a group of tall trees, an upright shape
might be better.

Above: *A traditional landscape format
accommodates the group of middleground
trees and the sweep of the path leading in
from the foreground.*

Above: *An upright rectangle shows less of
the trees, but allows for the introduction
of dark tones in the foreground to provide a
balance to them.*

What effect does the placement of the horizon have on a composition?

The placing of the horizon also has a bearing on creating space. For example, you can often give a better impression of a panoramic landscape, or an expanse of sea stretching away as far as you can see, if you place the horizon low letting the sky occupy about two-thirds of the picture space. For a hilly or mountainous landscape, on the other hand, you could cut the sky down to a small sliver at the top, but emphasise space by arranging lead-in lines that draw the eye in from the foreground and to the background.

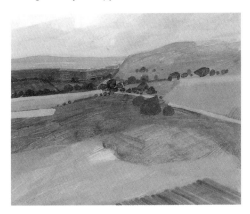

Left: *Here, the horizon is high, but there is a convincing feeling of space, with the diagonal lines of the foreground field propelling us into the picture and toward the distant hills.*

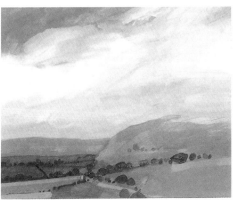

Left: *A low horizon gives an open, airy feel to a landscape and is especially suitable when there are dramatic cloud formations.*

Why do some artists get so close to the subject that parts of the objects get cut off?

Sometimes a composition is improved by cropping, which means allowing part of the subject to go out of the frame. Tall trees in the foreground of a landscape, for example, could extend from top to bottom of the picture. This would stress the spatial relationships, because cropping foreground elements brings them firmly to the front of the picture plane to act as a frame within the frame for the landscape beyond. Many artists find cropping is a useful compositional device for flower paintings, too.

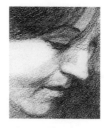

Above: *The close-up view provides a strong composition based on two intersecting triangles, the pale one of the face and the darker one of the background.*

Above: *Cropping the tops of the flowers focuses attention on the central blooms, the vase and its shadow.*

Left: *The foreground tree trunks balance the verticals of building and reflections. Cropping them at top and bottom brings them forward in space.*

Besides viewpoint and format, is there anything else I should consider when composing a painting?

Yes, you should also consider the focal point, which is not a 'point' but some part of the subject that you will make more prominent than the rest.

It is not essential for paintings to have a centre of interest, or focal point, but many do. Often this arises directly from the subject. When you choose a

landscape to paint you may do so because you are attracted by some dominant feature, such as a building in the middle distance and this will automatically become the focal point. In a full-length portrait, the natural focal point is the face and in a head-and-shoulders portrait it is the eyes. But sometimes you will need to determine the focal point yourself. In a still life, for example, you could emphasise one object through colour or tonal contrast.

Where you place the focal point in spatial terms depends upon how much space you are dealing with. In landscape it is traditionally placed in the middle distance, which has the effect of leading the viewer's eye into the scene. A good painting invites the viewer to participate.

Remember the rule of asymmetry and do not put the focal point in the centre of the picture. This would make it too obvious and the eye would travel straight to it instead of journeying around the picture from one area to another.

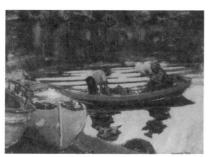

Above: Dawn at the Boatworks, *W. Joe Innis. The strong tonal contrasts in the centre of the picture, emphasised by the dark background, draw our eyes to the figures in the boat. But equally important is the way the shapes are orchestrated. The diagonal in the foreground leads to the curving side of the grey boat and then to the long, elegant shape of the rowing boat. This finds an echo in the less obvious curves of the figures and their reflections and is contrasted with the horizontal lines of the ripples behind.*

Above: *At one level the painting can be read as an abstract arrangement of shapes, with the elongated curve setting the key for the composition. Notice how the negative shapes of the pale water in the foreground play as important a part as the positive reflections themselves.*

ARTIST'S TIP

Here's a good rule of thumb for placing your focal point: Imagine a noughts and crosses grid superimposed on your painting surface. Any one of the four intersections of lines would be a good place for a focal point.

Can you show me an example of a painting without a focal point?

In this painting of a bandstand, the focal point has been played down. In a landscape, human-made features, such as buildings, will always stand out against the natural ones and they risk becoming over-prominent.

Right: Although the focal point is not emphasised, our eyes are led into and around the picture, from the group of figures on the right to those on the left and then to the bandstand. The light shape between the trees leads down again from the top of the picture.

How can I make the focal point stand out from the rest of the painting when I want it to?

Generally speaking, you will want to use one or more types of contrast in and around the focal point to attract the viewer's eye. For example, you might use brighter colours, more contrast between light and dark colours, sharper edges, more detail, or more highlights and dark accents. But you do not have to do this with the entire object that is your focal point. In fact, it is often better to accentuate just a part of an object or area.

Also you want to draw attention to the focal point – that is why it is there – but to do so subtly, through a system of visual signposts. Our eyes naturally follow diagonal or curving lines and these are often used to lead toward a centre of interest. In landscape they can take the form of a path or river running in from the foreground. In a still life or flower group, folds of drapery could serve the same function.

Above: *With any portrait, the eyes are a natural focal point. But notice how the artist used sharper edges and more detail to help draw your attention to the eyes. Notice, too, how more contrast in light and dark in and around the eye on the left makes that one stand out more than the other.*

Left: Bandstand at Greenwich Park, *John Rosser. The pretty bandstand is the focal point, both because it is human-made and because it is the theme of the picture. But the artist's main interest was in capturing the carefree atmosphere of a sunny afternoon in the park. He therefore treated the bandstand delicately, so that it blends with the background trees and foreground figures. The use of repeated colours, with yellows and blues appearing throughout the picture, ensures compositional unity.*

Can you help me learn to work with colour?

Colour is perhaps the most challenging aspect of painting and to some extent, the best way to learn to work with colour is through practice. But it helps to have a basic understanding of colour theory, so let's start at the beginning with the colour wheel.

Red, blue and yellow are known as primary colours, because they cannot be produced by mixing together other colours and are completely unlike one another. On the colour wheel, which is the standard device for showing colour relationships, they are placed at equal distances from one another. Between them lie the secondary colours – orange, green and purple – which are made from mixtures of two primaries.

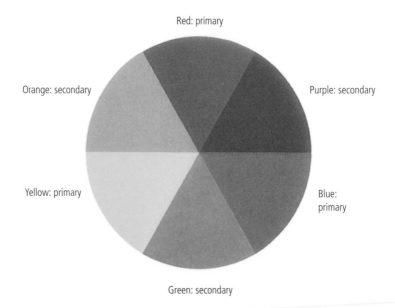

Red: primary

Orange: secondary

Purple: secondary

Yellow: primary

Blue: primary

Green: secondary

Above: Printer's colour wheel: This six-colour wheel, made with printing inks, shows the three primary colours and three secondary colours, which are mixtures of the primary on either side of them. The wheel could be extended to twelve or even twenty-four colours showing a wider range of secondary colour mixtures, but there would still be only three primaries.

The printer's colour wheel, shown below left, has only three primary colours, because these are all the printing process requires to produce a huge range of secondary colours. But the pigment wheel, shown below, has variations of each primary colour, such as cadmium lemon because in artist's pigment there is no such thing as a pure red, yellow, or blue. That is why the recommended starter palette (*see page*

36) contains more than one of each shade. So to mix a secondary colour, you must first decide which version of each primary colour to use for the shade you want. For example, red and blue make purple, but cadmium red mixed with any of the blues in the palette will lend it brownish hues; cadmium red and cadmium yellow will make a vivid orange; but lemon yellow and crimson will produce an orangey brown.

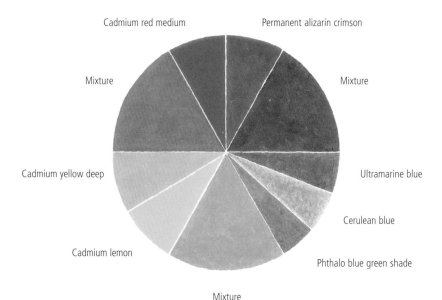

Cadmium red medium

Permanent alizarin crimson

Mixture

Mixture

Cadmium yellow deep

Ultramarine blue

Cerulean blue

Cadmium lemon

Phthalo blue green shade

Mixture

Mixture

Above: *Pigment wheel: This painted wheel, made with the selection of primary colours given for the starter palette (see page 36) shows that they do not all correspond with the pure primary values of the printed wheel. The secondaries are mixtures of the primaries on either side, but of course, a much larger selection could be achieved by varying the primary components. Some possible mixtures are shown on page 174.*

Why do I need two of each primary colour and how do I use them?

The painted wheel (*see page 173*) shows that the reds, yellows and blues all have a slight bias toward some other colour. Ultramarine, for example, veers toward red and phthalo blue toward green. The most vivid secondary colours are made by mixing the pair of primaries with a bias toward each other, while more muted hues are produced by pairing those with an opposite bias. In each of these charts – except the one for the green mixtures, which contains two pairs of 'like' primaries – the top row shows two 'like' primary colours with the secondary mixture and below are mixtures of 'unlike' primaries. The latter can provide some useful ideas for mixing greens and browns, where you often want subtle rather than vivid colours. The range of shades can be extended by varying the proportions of the colours.

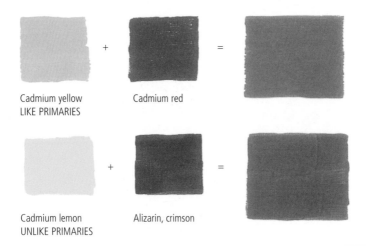

Cadmium yellow
LIKE PRIMARIES
\+
Cadmium red
=

Cadmium lemon
UNLIKE PRIMARIES
\+
Alizarin, crimson
=

Mixing oranges: The first mixture is the brightest, ideal for the pure colours of flowers, or for oranges in a still life. The second mixture would be suitable for subjects, such as autumn foliage, or mixed with a little more white for skin tones.

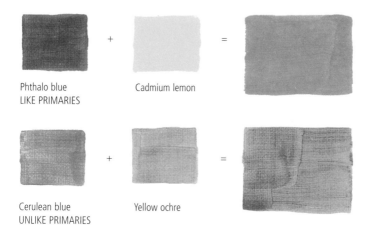

Phthalo blue
LIKE PRIMARIES

Cadmium lemon

Cerulean blue
UNLIKE PRIMARIES

Yellow ochre

Mixing greens: The top mixture, of an acid yellow and a greenish-blue, might be used in a portrait or still life featuring a fabric or ceramic of this colour, but is too brash for the greens of nature. For more natural-looking greens, it would be better to use a combination of 'unlike' primaries, one of which is shown in the second row.

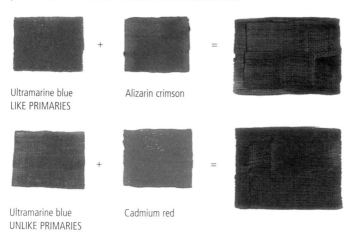

Ultramarine blue
LIKE PRIMARIES

Alizarin crimson

Ultramarine blue
UNLIKE PRIMARIES

Cadmium red

Mixing purples: A true purple can only be made from the red and blue shown in the top row, so for purple flowers these must be your starting point. But for the red brown of some tree trunks, or mauvish-browns of shadows, mixtures of the 'unlike' primaries may be more satisfactory.

Is it better to buy pre-mixed secondary colours, or to mix them from primary colours?

Although you can mix most of the secondary colours you need from two primaries, some ready-made secondary colours are stronger and brighter than those you can mix. It is almost impossible to mix a purple to equal the intensity of the various tube purples and the tube version of cadmium orange is more vivid than a yellow-red mixture. The starter palette (*see page 36*) includes one purple, but you may need another, along with an orange, especially for floral subjects.

Mixture of crimson and ultramarine

Tube colour: Dioxazine purple

Mixture of cadmium red and cadmium yellow

Tube colour: Cadmium orange

How do I mix natural-looking colours?

The range of unobtrusive browns, greys and beiges classed as neutral are important in painting, because they set off the other colours and make them appear brighter by contrast. They can be more difficult to mix than secondaries for three reasons. They often involve mixing more than two colours, neutrals are also known as 'tertiary,' because they typically have three colour components. They are often hard to identify in terms of paint colours and

sometimes even to name. Finally, they are affected by surrounding colours. A bluish or purplish-grey that seems right on the palette may look too bright when placed next to an even more neutral colour.

This is because none of these colours conforms to the dictionary definition of neutral, i.e., without bias. The only true neutrals would be black and white, which are not classed as colours and grey that is a mixture of the two. In painting and in nature the so-called neutrals all have a colour bias. Grey will rarely be a straight mix of black and white; it may have a blue, mauve, or

brown tinge. Browns may veer toward red, green, or blue; and beiges toward pink or yellow.

You can make neutrals by adding small quantities of colour to black or brown, but this can give dull results. Neutrals with more character can be achieved by mixing the three primary colours – or one primary colour and one secondary, which is in effect the same thing, a combination of three colours. Some of these mixtures are shown opposite, but there are many other possibilities. Artists develop their own recipes for making neutrals, so make a note of any successful mixtures.

Below: *Three-colour mixtures. Because the primary colours are unlike one another, a mixture of all three in equal proportions produces a neutral. If you want a neutral with a more positive colour bias, increase the quantity of one of the colours. To lighten the shade, add white, or water if you are using transparent paint.*

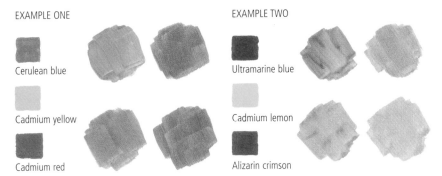

EXAMPLE ONE

Cerulean blue

Cadmium yellow

Cadmium red

EXAMPLE TWO

Ultramarine blue

Cadmium lemon

Alizarin crimson

These are four of the many mixtures made from three primaries. All colours look darker when the paint is used thickly, so for opaque methods, add white for a pale neutral.

Different versions of the three primary colours were used for these tertiary mixtures. Any of these primaries could be mixed with them to increase the range of neutrals.

Are there other ways of mixing neutral colours?

Yes, I'd like to tell you about two other options. The first is mixing complementary colours, which means mixing any two colours that lie opposite each other on the colour wheel.

There are three pairs of these: red and green, blue and orange, yellow and violet, each comprising one primary colour and one secondary. Juxtaposing these colours in a painting creates vibrant, sometimes startling effects, but when mixed together they cancel each other out and are therefore a quick way of mixing neutral browns and greys. By varying the proportion of complementary colours, an extensive range of tertiary mixtures can be produced.

Cadmium red Chromium oxide green

Cerulean blue Cadmium orange

75% red 75% green

MIXTURES OF RED AND GREEN

75% orange 75% blue

MIXTURES OF BLUE AND ORANGE

Cadmium yellow Dioxazine violet

75% yellow 75% violet

MIXTURES OF YELLOW AND VIOLET

ARTIST'S TIP

Every artist should master four important key terms about colour: Hue refers to the colour by its name, such as red, blue, green. Intensity refers to the purity or strength of a colour. Value refers to the lightness or darkness of a colour. And temperature refers to the relative warmth or coolness of a colour.

What is the second option?

Davy's grey is a colour specially formulated for the purpose of toning down, or neutralising, colours. This is useful if you want to reduce intensity but do not want a true neutral.

Davy's grey is one of the more transparent pigments, so if you are using opaque paint rather than the transparent colour shown here, you may need to add a little white also.

Red and green	Yellow and violet	Orange and blue
Strong	Strong	Strong
Muted	Muted	Muted

Do you have any other tips or advice on mixing neutrals?

Yes, it is important to put everything in context. These examples show how colours are affected by neighbouring hues. The neutral colours look less neutral when seen against a grey made by mixing black and white than when juxtaposed with vivid colours. When you paint, apply some of the brighter colours before mixing the neutrals, so that you have something to judge them against.

A brownish neutral against orange

The same neutral against grey

A green-grey neutral against blue

The same neutral against grey

What does it mean when artists talk about 'tone' or 'tonal value' in relation to colour?

The terms 'tone,' 'tonal value,' or just 'value' all describe the lightness or darkness of a colour, regardless of its hue. All pure colours have an intrinsic tone. Reds are much darker than yellows and the blues and purples (with the exception of cerulean blue) are darker still. You will often need to lighten these darker colours. Applying undiluted ultramarine blue for a sky, for example, would not create a realistic effect.

When you use the paint opaquely, you can lighten colours by adding white. For transparent watercolour effects, water performs the same function; the more diluted the paint, the paler the colour. But some colours cannot be lightened without changing their character. Red becomes pink when mixed with white, so to create highlights on a red object it is sometimes better to add yellow.

Right: *These swatches show each starter palette colour mixed with varying amounts of white to lighten them. Red loses its redness and the intensity of yellows and greens is reduced. The same applies when you add water for transparent applications. But purple and ultramarine blue become more intense when a little white is added because they are dark-toned, looking almost black if thickly applied and a slight lightening makes the colours emerge more clearly.*

Cadmium lemon + white

Cadmium yellow deep + white

Yellow ochre + white

Cadmium red medium + white

Permanent alizarin crimson + white

Dioxazine purple + white

Ultramarine blue + white

Phthalo blue green shade + white

Cerulean blue + white

Cobalt green light + white

Chromium oxide green + white

Row umber + white

Burnt umber + white

Why is it important to understand 'tone'?

Tone is important because the changes from light to dark help create the illusion of three-dimensional space and form.

Colour plays a central role in identifying objects. It is the light and dark variations of colour, caused by the fall of light, that make objects appear three-dimensional. The actual colour of an object is called its local colour. You must evaluate this and the tones you observe on an object. It is surprisingly difficult to judge tone, because we do not naturally see in terms of light and dark; our eyes are more receptive to colour. Half-close your eyes, to reduce the impact of the colour and blur detail.

Below: *Painters make a continuous series of comparisons and judgments. Instead of looking at an object or area in isolation, assess its tone against those of neighbouring objects to decide whether it is lighter or darker overall, or lighter in some places and darker in others.*

Lemon

Apple

Aubergine

The lemon looks like a cut-out, because the overall tonality is so much lighter than the background.

The local colour of the apple is darker than that of the lemon, but lighter than the maroon background.

The aubergine is darker than the background, but the shiny surface creates much lighter highlights.

The black and white photograph reveals a dark shadow on the underside that is only slightly lighter.

The shiny surface reflects the dark maroon, causing dense shadows equal in tone to the red above the apple.

The soft highlight running along the top is equal in tone to the left side of the apple and middle of the lemon.

Do you have any additional advice on learning to correctly identify tonal values?

Yes, I would also recommend using a grey scale. A grey scale is a useful aid to judging tone. It will help you to learn the intrinsic tone of each of the colours in your palette and to assess the variations caused by light and shade. A common mistake is to overstate the darks. If you hold the scale up against a dark area in your painting you may find that it is nowhere near the black end of the scale. Here you can see how the tube colours fit into a tonal scale, with yellow near the top and blue and purple near the bottom.

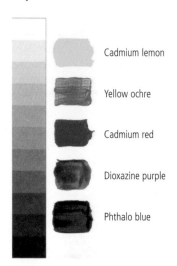

Cadmium lemon

Yellow ochre

Cadmium red

Dioxazine purple

Phthalo blue

What is the best way to mix a very pale tone, almost white colour?

When you want to mix a very light colour such as pale pink, always start with white, adding small amounts of colour until the tone is right. The pure colours are much stronger than white and if you work the other way around you may have to use a large quantity of white to counteract their effect.

Above: *Pick up a small amount of the darker colour with the tip of the brush. Mix it in well, adding more paint if needed.*

If I want to darken a colour to create a very dark tone, should I add black?

Using black to darken colours can also change their appearance. It does not affect the nature of blues and purples and works well for the neutral colours, such as browns and greys. However, it can have unexpected effects, including changing yellow into green and red into brown.

Cadmium red

Cadmium yellow

Alizarin crimson

Cadmium lemon

With black added

With black added

With black added

With black added

Is there another way to darken a colour, especially reds and yellows?

For the colours that cannot be mixed with black to darken them, it is possible to achieve deeper tones by mixing in a darker related colour.

Add dioxazine purple to alizarin crimson

Add yellow ochre to lemon yellow

Add burnt umber to cadmium red

ARTIST'S TIP

A useful method of judging both tones and colours is to mix some paint and hold your brush, with the paint on it, in front of the subject. You will be able to see immediately whether the paint is too light or dark, or too warm or cool and you can amend the mixture accordingly.

That makes me wonder if I can use other light colours to lighten a dark colour.

Yes, you can! If you do not want to use white, lift the tone by mixing in a related but lighter-toned colour. Some examples are shown below.

Add cerulean blue to
ultramarine blue

Add lemon yellow to
yellow ochre

Add yellow ochre
to raw umber

Earlier you showed a colour wheel that had different variations of the primary and secondary colours. Can you explain the variations in more detail?

Yes, this is a good time to learn about another property of colour: temperature. Artists classify colours in terms of temperature. Reds and yellows and all mixtures containing them, are perceived as warm, while blues, blue-greens and blue-greys are cool. The warm colours tend to advance to the front of a picture and the cool ones to recede. One of the ways of creating the illusion of space in a landscape is to use warm colours in the foreground and cooler ones for the middle and far distance.

But like hue and tone, colour temperature is relative. Blue, although on the cool side of the colour wheel (*see opposite*), can appear warm next to a cool, neutral grey, so it is not just a question of painting the distant hills blue – you must relate the blue to the other colours. There are temperature variations within the same colour groups. Some blues are warmer than others. The same applies to reds, yellows and greens. Even the so-called neutral colours have a warm or cool bias.

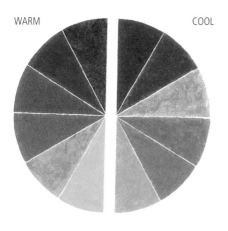

WARM COOL

Left: *Colour temperature: The colours on the right-hand side, greens and blues shading into purple, are cooler than those on the left, where yellows shade into oranges, reds and finally magenta, a red-purple.*

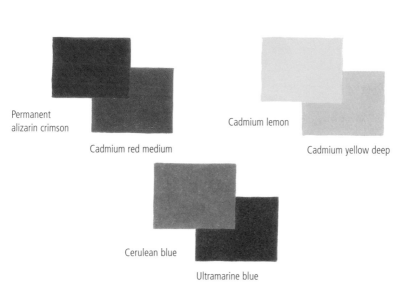

Permanent
alizarin crimson

Cadmium red medium

Cadmium lemon

Cadmium yellow deep

Cerulean blue

Ultramarine blue

Above: *Warm and cool primary colours: These swatches show two reds, two blues and two yellows from the starter palette (see page 36). In each case, one is warmer than the other. The crimson has a slight blue-purple bias and is cooler than the cadmium red. The lemon yellow is acid and greenish, cooler than the more orange cadmium yellow. Cerulean blue is cooler than the slightly purple ultramarine.*

Can you explain what you mean by a colour moving forward or receding?

This quality is easiest to see when you look at a colour in the context of another colour near or around it. Look at these swatches, for example. The first four squares show how the warm red and yellow stand forward from the cooler blue and blue-green in the centre.

But when these colours, which would normally be considered recessive, are seen against a neutral grey, as in the squares on the right, they in their turn advance. The most vivid colour will always stand out even if it is technically a 'cool' one.

Blue green on orange

Blue-green on yellow

Blue-green on grey

Blue on orange

Blue on yellow

Blue on grey

So if I want an object to have presence, I should paint it with warm colours, right?

That would be one way to achieve your goal, but the relative warmth or coolness of a colour is not the only thing that makes it advance or recede. Thick paint has a stronger presence than thin and will thrust itself forward regardless of the colour. The Old Masters, notably Rembrandt, created powerful three-dimensional effects by using thin paint for the backgrounds of portraits, with thick impastos (*see page 118*) for the highlights on faces, or details of clothing.

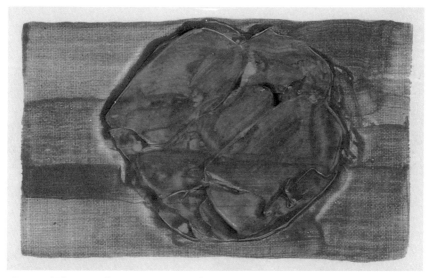

Above: *Thick paint will appear to advance from a painting, while thin appears to recede.*

ARTIST'S TIP

If a colour does not look right when you apply it, remember that you can alter it later with transparent glazes or washes of water-diluted paint.

Occasionally, I mix colours that just look dull and lifeless. Where am I going wrong?

When colours are mixed, they become reduced in intensity, that is, less brilliant. A secondary or tertiary colour is seldom as bright as any of its components. That is why most teachers recommend mixing no more than three colours. When beginning artists fail to achieve the colour they want, they sometimes panic and mix four or five colours, which usually results in muddy-looking colours.

Unless you are mixing neutrals (*see page 186*), it is wise to restrict yourself initially to two-colour mixtures plus white. You will be surprised at how many hues, or gradations in colour, you can achieve with the starter palette colours. A selection of possible mixtures is shown here, but you can extend the range considerably by varying the proportions of the colours and adding different amounts of white.

Right: *The chart shows a range of two-colour mixtures you can achieve with the colours in the starter palette (see page 36). The thirteen starter colours are shown on the first row, first from the tube and then as a 50:50 mix with white. The rest of the chart shows each colour mixed with the other starter palette colours and the mixtures with white added. You can create more colours by varying the proportions of the mixtures and by adding varying amounts of white.*

Column headers: Cadmium lemon / +50% white / Cadmium yellow deep / +50%white / Yellow ochre

Row labels:
Tube colour
Cadmium lemon
Cadmium yellow deep
Yellow ochre
Cadmium red medium
Permanent alizarin crimson
Dioxazine purple
Ultramarine blue
Phthalo blue green shade
Cerulean blue
Cobalt green light
Chromium oxide green
Raw umber
Burnt umber

+50% white

Cadmium red medium

+50% white

Permanent alizarin crimson

+ 50% white

Dioxazine purple

+ 50% white

Ultramarine blue

+ 50% white

Phthalo blue green shade

+ 50% white

Cerulean blue

+ 50% white

Cobalt green light

+ 50% white

Chromium oxide green

+ 50% white

Raw umber

+ 50% white

Burnt umber

+ 50% white

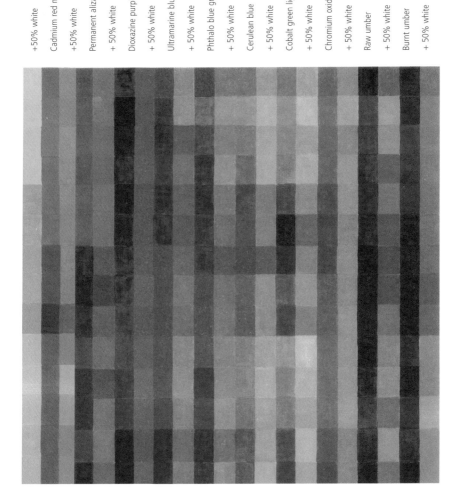

Watercolourists sometimes 'mix' colours by layering transparent glazes. Can I do that with acrylic glazes, too?

Yes, surface mixing is easy to achieve with acrylics. In watercolour painting the stronger tones and colours are built up gradually, by applying successive transparent layers of colour over one another. The same applies to acrylic, when used in watercolour mode (*see page 87*). You are, in effect, mixing colours on the working surface. This does not eliminate the need for premixing on the palette, since there are limitations to surface mixing. You can make colours darker, richer, or more muted, but you cannot make them lighter, because you are dealing with transparent paint. Although you can mix secondary colours on the surface – laying blue over yellow to make green, for example – it would be laborious to rely on this method for an entire painting. It can be effective in small areas: for example, you could paint a tree by laying a yellow wash and working over it with different strengths of blue. Make sure that you elect the correct primary colours for this (*see page 174*). It is a good idea to try out the effect first.

Right: *Although you would be unlikely to use the surface mixing method for every secondary colour in a painting, you might consider it for certain areas, because it creates interesting effects. Mixing a green from blue and yellow in the palette will achieve a smooth blend, but as you can see here, when you overlay colours the brush deposits the colour unevenly, producing a hue that varies in intensity within each brushstroke.*

Phthalo blue laid over cadmium lemon

Cadmium red laid over cadmium yellow

Ultramarine blue laid over alizarin crimson

Right: *Building up tones: When you use transparent paint you can darken colours and tones, but you cannot make them substantially lighter. So for watercolour effects (see page 155) you must build up the deeper tones by means of successive overlays, as shown here.*

Three separate applications of ultramarine

Three separate applications of cadmium red

Right: *Changing the hue: The nature of a colour can be altered either radically or subtly by means of colour overlays. You can also lift the tones to some extent. The cadmium lemon applied over the green in the first example lightened and intensified it.*

Blue and yellow laid over green

Purple and green laid over blue

So surface mixing is strictly used with a watercolour approach?

No. They are also useful when you need to alter colour balances in an opaque painting. Instead of overpainting with additional opaque colour, you can apply a watery wash. Use this to add a hint of blue to a shadow or increase the depth of colour in a sky. You can change colours most by laying dark colours over light, but you can also make a noticeable difference by working light over dark. A yellow wash over a green tree or field will produce a distinct colour variation.

Right: *Transparent over opaque: Do not reject the possibilities of transparent colour overlays even if you are working mainly with opaque techniques. If a colour looks dull, try laying a vivid hue over it, covering the entire area or selected parts.*

Phthalo blue over an opaque, heavy grey

Cadmium lemon over an opaque, muddy green

How do I know when I've really mixed the perfect colour?

When you begin painting a picture you may find your colours behaving unexpectedly. You mix the apparently perfect colour for something, only to discover that it looks too bright or too dull, too dark or too pale when you put other colours next to it. This is because colours are relative, changing in appearance according to their context. A brown that seems almost black on a white surface will look much paler if surrounded by black. A blue may show a greenish bias if juxtaposed with a more purplish blue.

Brown on white

Brown on black

Brown on grey

Above: *Relative tones: Neither colours nor tones can be judged in isolation. This brown looks darker on white than it does on black. In the third swatch, the brown is so close in tone to the surrounding grey that it is barely distinguishable; half-close your eyes and it disappears.*

ARTIST'S TIP

From time to time, you may choose to use a colour palette that is not the true, or 'local,' colours of your subject. Instead, you may choose colours for their symbolic meaning. Most of the Western world associates the same meanings with the same colours. For example, red is about passion, excitement and energy; yellow means joy and hope but can also mean deceit and betrayal; blue is often associated with peace, tranquility and trust; green means natural and healthy; purple usually symbolises both nobility and spirituality; and orange is for energy and enthusiasm.

What if I do not want to paint my subject in its true colours? Is it okay to adjust the colours in a different way?

Absolutely! In addition to describing subjects we see in the world, colour can be used expressively, to create a particular mood or atmosphere. Vivid colours and strong primary or complementary contrasts that call out tend to evoke a happy response. Dark heavy colours, such as browns, deep blues and purples can be powerful in a different way, giving an impression of stability and thoughtfulness. A portrait painter might express something about the character of the sitter through colour, choosing light, bright colours for a youthful subject and sombre ones for a graver figure.

Colours have different associations for each of us and these can vary. Red, for example, is the traditional colour for warning signs. In some contexts it can be aggressive, but it can also be cheering. Blues, greens, greys and pastel colours, the most usual choices for interior decor, are unassertive. A painting dominated by red is likely to draw attention more immediately than one utilising blue-green harmonies or light-toned neutrals.

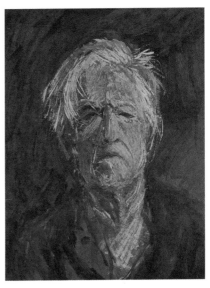

Right: Portrait of the Artist's Father, *Gerald Gains. Using dark colours: The sombre palette chosen for this portrait, together with the strong tonal contrasts and expressive brushwork, give the painting both atmosphere and drama.*

Can you show me an example of a painting done with all bright colours?

Here's a great example of a bright painting. This still life conveys a joyous mood through the use of the primary colours shown on the left and equally vivid secondary colour mixtures – the green and the orange.

Left: Summer Fruits, *Sara Hayward. The artist did not attempt a realistic depiction of this subject; the theme of the painting is colour and pattern.*

ARTIST'S TIP

Artists often debate the use of black. If you're trying to create a natural-looking range of colours in your work, avoid black because it actually doesn't exist in nature. But if you want to be creative with your colour choices, go ahead and use it for colour mixing or as an accent, as this demonstration painting shows.

Is it also possible to create a quieter mood with colour?

Of course! You can create a gentle atmosphere by avoiding contrasts and using harmonious colours, which are those close to one another on the colour wheel. A landscape painting is likely to have this restful quality because the colours of nature are harmonious: greens from yellow-green through blue-green; skies comprising shades of blue and mauve. Flower painters often set up groups of harmonising colours, such as mauves and pinks, or shades of yellow and orange, with perhaps one or two white blooms to provide tonal contrast.

The creamy yellow of the sunlit clouds links with the yellow on the sides of the houses and the small flowers in the foreground.

The mauve-greys in the immediate foreground are repeated in the sky and the muted reds suggesting flowers echo the distant rooftops.

Above: Poplar Blues, *James Harvey Taylor. The artist chose a scheme of cool, muted colours, which express the gentle feeling of this landscape. He carried them through the entire painting, repeating the blues and blue-greys of the trees in the foreground and in the sky. He rejected any vivid colour accents; the foreground flowers, for example, were intentionally subdued. Although the contrasts of colour and tone are not marked, this painting is lively and full of interest, with each part of the composition containing a number of different, but closely related colours.*

Do you have any final advice on composing a painting?

Yes, now that we've discussed shape and colour in depth, I want to mention one final aspect of good composition: the tonal structure of the painting. Just as the colours in a painting must work together, so must the tones. A painting needs an overall tonal structure, in which the lights and darks balance and counterpoint one another, forming a pattern that is independent of the colours used. Look at some black and white reproductions of pictures by professional artists to see how this aspect of painting works at its best.

You do not need heavily marked light-dark contrasts to achieve a tonal pattern, but there must be some contrast, or the picture will look flat and dull. The amount of contrast will depend upon your subject and the lighting conditions.

Portraits are sometimes lit to provide dramatic contrasts of tone, but the majority of subjects seen under natural light are in the mid-toned range. This means that neither the lightest nor the darkest tones will approach the black or white end of the grey scale. A landscape seen under strong sunlight will have more tonal contrast than on an overcast day, but it will still contain no pure whites.

The dark upright shapes of the figures and vertical box are counterpointed by the middle- and light-toned horizontal bands in the background.

Above: After Jean de Florette, *Barrington Magee. This degree of tonal contrast would never be found in the real world because the prevailing light would modify the blacks of the garments, creating areas of middle to light grey. But this is not a realistic painting and the artist used high contrast and hard-edged shapes to emphasise the immobility of the figures.*

The darkest tones, in the foreground hedge, tree and shadow, are nowhere near the black end of the grey scale.

Above: Castle Morton, *Paul Powis. A high tonal key was used here, which means that there are no really dark tones, yet there is enough contrast to make an interesting composition and the subtle modulations of tones within each area – for example, the clumps of trees – describe the form clearly. The picture conveys an impression of shimmering heat, with the sun bleaching out the colours and reducing contrast. In landscape painting it is important to judge tones as well as colours accurately, because it is through both of these that you express the quality of light that is inherent to any outdoor scene.*

How can I make sure I have a good tonal structure in my paintings?

Some artists like to plan the tonal structure before painting by making monochrome sketches. This is a useful exercise and helps to concentrate the mind. Use a soft pencil (4B to 5B) or a brush and diluted drawing ink. Do not try to include every tone you can see, or the drawing will become muddled. Look only for the main areas of light and dark and two or three middle tones.

As you paint, you will want to repeatedly check to make sure your tonal structure remains intact. Like colours, tones must be judged one against the other rather than being viewed in isolation; something looks dark only because a neighbouring thing is lighter. It helps to work on a mid-toned coloured ground (*see page 135*), which gives you a basis against which to assess the darker and lighter tones. If you are using a white surface, do not begin with the lightest tones, because this may cause you to pitch the entire painting too high. Instead, block in the dark and middle tones first and work up to the lights. Make comparisons throughout the painting process.

Above: *Before embarking on a painting it is a good idea to make a series of small, quick sketches to help you to decide on the final composition. The artist made several, tiny, 'thumbnail' sketches of a boatyard trying out the various alternative arrangements before committing the composition to canvas.*

Once I've determined the mood I'm trying to express and the tones and colours I could use to communicate it, how do I make it work?

In a good painting all of the colours work together to create a unified image. A common mistake is to view each object or area separately. Choose warm or cool, or bright or muted colours and then work at the entire picture all of the time rather than bringing one part to a higher stage of completion than others.

Let's look at this example in which the artist heightened the colours to create a mood. It works because it is unified. Whether you brighten the colours in this way or stick to naturalistic ones, you can link the various parts of the picture by using colour echoes, that is, by repeating the same or similar colours from one area to another. Some landscapes are less successful because the sky does not seem to relate to the land. Create colour relationships by using touches of sky colour among the greens of trees. In a still life, use muted versions of the foreground colours for the background, linking the two planes.

Any of the colours used in this area might look too bright if set against a neutral, but they work perfectly together.

This squiggling brushstroke of brilliant red does not describe any specific landscape feature; its purpose is to contrast with the turquoise and to echo the reds in the foreground and hills.

Above: Towards North Hill, *Paul Powis. This painting also has perfect unity of colour. The colours were heightened to give an impression of intense light and heat. Warm colours predominate, with reds, yellows, oranges and mauve-blues offset by the cooler but equally vivid turquoise in the central area. The artist brought the composition together with colour echoes, repeating the yellows and reds from foreground to hills.*

10
DEVELOPING YOUR PERSONAL APPROACH AND STYLE

What advice can you give me on developing my own approach to painting?

When it comes to developing yourself as an artist, there really is no substitute for practice, for simply standing at the easel and working at it. Knowledge of colour, composition and tone is just as important as it ever was and there is still no easy way of learning how to draw. But the best way to find out is to have a go – if possible, working directly from the subject. Whether you choose landscapes, still lifes, figures or abstract compositions, find a subject which really interests you. Do your best to make it a success but, above all, enjoy doing it!

Painting is not an activity which is separate from everyday life. The more involved you become, the more you will come to realise that choosing a subject is not an arbitrary decision to be made when the paints are out and the easel set up. How we perceive the world around us is bound up with other aspects of our lives – who we are, what

we do and where we live are all factors which influence our perception, affecting not only what we see but how we see it.

The problem is how best to record our experiences and ideas for when we need them. Quite often we are impressed by something we see – possibly a scene or how the light falls in a particular way, or perhaps a flash of memory, a reminder of something from the past. We are all struck by certain things at various times and these moments can provide a rich source of subject matter, providing they are somehow recorded and stored for future use. It is not easy to define 'personal vision', but it is certainly simpler and far less mysterious than it sounds. For the artist, a great deal depends on documentation – on developing a visual filing system which will jog the memory and can be referred to when occasion demands.

How can I keep track of all the great ideas I find in the world around me?

A sketchbook is an ideal tool for recording what you see and the things that inspire you. You do not have to work on a large scale and a small pad which you can slip easily into your pocket

is all you need to record a wealth of information which might otherwise be forgotten.

You may feel self-conscious at first and dislike the idea of people looking

over your shoulder while you work. But once you get into the habit of sketching in public places you will find that people become less interested as you become less embarrassed and that once you have started work you will not notice what is happening around you.

Your scribblings do not have to look like a finished drawing and it doesn't matter if the image is unrecognisable to anyone except yourself. The important thing is that you are providing yourself with a clue, a starting point for a painting – however far into the future this might be. By taking the trouble to keep your eyes open, you will begin to identify your own particular likes and dislikes – in fact, to develop your own style. A sketchbook can include colour notes – either in the form of written reminders or by indicating the actual colour in paint or crayon. It can also be used to record tone – the comparative light and dark areas of the subject as well as where the highlights and shadows fall – and other information which can be invaluable when composing a painting from memory or imagination.

One of the most difficult subjects to paint without reference is the human figure. Here the sketchbook can be especially useful because most of us come into contact with people every day of our lives, often at times when there is ample opportunity to make a quick sketch. At work, at home, on a train, in cafes – all of these places and many more, offer a vast range of human activity and a chance for you to capture poses, expressions and movements which can be stored and drawn on at a later date. There is nothing more frustrating when planning a figure composition than not having enough reference to hand and having to rely on memory.

Above: *A quick sketchbook drawing becomes the subject of a painting. Above, the artist uses a grid to enlarge the image on to a support.*

Do you recommend working from life?

Yes, definitely. Many painters prefer to have the subject in front of them, whether working from a model, out-of-doors, or from a still life. Photographs and drawings are indispensable aids, but it can be difficult to capture the atmosphere of the subject when working entirely from such references. Your personal feelings and reactions to a subject are as important as accuracy – and there is no substitute for working directly from the subject.

Left and below: *There is no substitute for taking your sketchbook or easel out and about and working from life.*

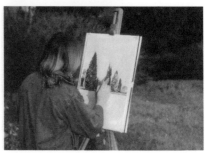

Do you have any tips or suggestions for working from life?

Practical considerations play a crucial part when it comes to deciding what to paint. Generally, you can only work outdoors if the weather is good and even then you need to go prepared – appropriate clothing and a portable easel are essential. Working indoors is usually easier but, unless you have a room which is used specifically for painting, you should set up your equipment and subject in an area where they can stay undisturbed until the work is finished and where there will not be a stream of people and interruptions to distract you.

Working outdoors can be daunting because there are so many unknown factors. Not only is the weather often unreliable, but the light can change constantly, making it difficult to establish the basic colours and tones in a painting. These are occupational hazards, but a little planning is helpful. Take a sketchbook and camera with you to use if you feel the elements are against you or that you aren't going to finish your work in the available time.

Interior scenes and still-life paintings are usually easier. You have a captive subject and can work in your own time. Sometimes you will paint perishable things, such as flowers and this imposes a time limit. But, generally, the pace is slower and you can take a more leisurely approach. The problem of changing light is still present, but this can be solved by working on two or more paintings at different times of the day – catching the morning light in one and working on another in the afternoons.

Keep an open mind about the subjects you choose. Obviously, some things will attract you more than others and certain subjects will be more convenient, but do not close your options too early and miss the opportunity of painting from a broad range of subjects to find out what really interests you and what you are best at. Many artists eventually become involved with a particular theme or develop their own specialist area but no successful painter has ever worked exclusively from one subject without at least starting off from a broader base.

Nor should subject matter be divided too readily into separate categories. The terms 'landscape', 'still life', 'portrait' and so on are labels of convenience rather than rigidly different types of painting. The wildlife painter who understands landscape is better able to place the subject in a convincing setting, and the portrait painter who is also interested in still life is likely to produce an integrated overall composition.

Above: *Changing light can alter a scene dramatically within the space of a few hours. These photographs were taken at I pm, left and 6.20pm, right.*

What will I need to take with me if I go outside to paint a landscape on location?

As well as paints, brushes, a palette and a working surface, a viewfinder (*see page 174*) will help you plan the composition. If you are working on paper rather than canvas or board, you must have a support. It is not necessary to buy a ready-made drawing board; particle board, plywood and Masonite are all quite satisfactory. Water is essential and a supply of rags or paper towels for drying brushes and cleaning up. If you work standing, you need an easel and a small folding table for your equipment. If you prefer to sit, a chair is ideal.

Do you recommend working from photographs?

For a beginner, working from life is the best way to go. Once you've mastered your medium and some basic techniques, then you can start to use photographs as an additional source of reference material. Refer to photographs without falling into the trap of copying them. Real life has more colour and emotion.

In the photograph, the foreground shadows are unrealistically dark, making it hard to see the legs of the standing figure.

Tonal structure and arrangement of figures worked out fully in pencil sketch. Colour notes serve as reminders.

Above: Lake Orta, Italy, *Alan Oliver. The photograph provided a basis for the composition, but is inadequate in many respects. The colours are muddy and dark, the details are unclear and there is no strong focal point. Knowing the limitations of the camera, the artist made colour notes on his sketch, in which he also worked out an improved composition.*

What are the benefits of learning to paint by copying the works of great masters?

In the past art students made copies of other people's pictures to learn about technique, colour and composition. While this method encouraged sound draughtsmanship and high technical standards – and copying should never be underrated as a means of learning – it seems a pity to neglect the real world for so long in pursuit of academic skills.

Copying the work of other artists is not a satisfactory long-term solution to the problem of finding a subject but working from images which have already been 'processed' can be extremely helpful in some circumstances.

For instance, when confronted by a real subject you are also confronted with a bewildering mass of detail which could not possibly be accommodated in a painting. The problem is one of selection – of deciding what to include and what to eliminate. Here the experienced artist has the advantage and, whereas the amateur painter can lose confidence and feel undermined if every detail is not accurately included, the more experienced painter will already have developed a sense of priority and be able to pick out those elements that are of special interest.

There are, therefore, occasions when it can be helpful to copy the work of other artists and to gain first-hand knowledge of how they cope with the process of selection and elimination. In the same way, painting from a photograph – where the subject has already been selected and the three-dimensional image presented in a two-dimensional form – leaves you free to concentrate on the formal problems of colour, tone and composition without having to worry about making it 'look real'.

Copying a picture is far more beneficial than just looking at it. However much you concentrate and however familiar you become with a painting or the work of a particular artist, there is no substitute for actually reconstructing the picture. Not only will you find out how the artist worked, what colours were used and so on, but you will also learn something about what the artist thought and felt about the subject.

Obviously it would be boring and counterproductive to imitate other people's style indefinitely. Hopefully you will not be content with copying for long and will want to get on with your own work. But learning from others can do no harm. For the serious student it is probably the most effective means of finding out about technique; for the less confident beginner it can often be a painless way of starting to paint.

What is the key to a successful landscape?

The outdoor world offers an infinite number of enticing scenes for the artist, from dramatic mountainscapes, seascapes and wide panoramas to intimate corners of a park or yard. It is not surprising that landscape is the most popular of all painting subjects. There is also the pleasure of sitting outdoors painting a favourite spot, or sharpening memories of a holiday by recreating scenes from photographs or sketches.

Landscape does not demand the level of accuracy of portraiture or architectural subjects, but that does not make it an easy option. The painting will not succeed unless you think about its composition. You may feel that you do not need to compose a landscape because nature has done this for you, but when you paint from life you arrange what you see in a particular way. A scene presents many aspects and only you can decide which to focus on. For example, will you place a dominant feature, such as a large tree, on the right, on the left, or in the centre? Should it be in the foreground or farther back, in the middleground? A viewfinder (*see page 166*) will be an aid when making these choices.

If you are working from a photograph, do not copy the format and composition automatically. Use strips of paper to mask the photo in different ways. A vertical or square shape might work well, or you could base the painting on a small area of the photograph.

Above: Sunset, Cannon Hill, *Daniel Stedman. In landscape painting, light is inseparable from the subject. An outdoor scene consists of more than its physical components, such as trees, hills, or fields, because all these features are seen under a certain kind of light dictated by the time of day and the weather. This subject might have seemed prosaic at another time of day, but is given drama by the setting sun, which deepens and enriches the colours and casts a blue light on the trees and foreground.*

How can I add depth to a landscape?

There are two main ways of creating the impression of space and depth in landscape. One is by careful observation of the effects of linear perspective, which make things appear smaller the farther away they are and the other is by control of colour and tone in the painting.

It can be hard to assess relative sizes when you are out in the field. You may know the size of a lake because you have walked around it, but if it is in the middle or far distance, it will appear tiny compared to a foreground feature such as a shrub. One way to check is to hold a pencil or paintbrush in front of you at arm's length and slide your thumb up and down it to find the height or width of a distant feature, then repeat the process for something nearer and compare the measurements.

As objects recede in space, they become not only smaller, but also less distinct, with narrower contrasts of tone and paler colours. This effect, caused by dust and moisture in the atmosphere, is called aerial or atmospheric perspective. The colours also become bluer or cooler. Create the illusion of space and depth by using progressively cooler colours for the middle and far distance, reserving the warm colours and strong tonal contrasts for the foreground.

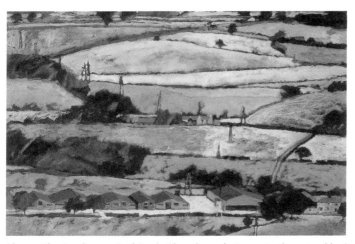

Above: Blue Landscape, *Paul Powis. There is no sky to create the natural horizon line that suggests space and there is little or no greying of the colour in the distance. The impression of the receding landscape is conveyed through observation of linear perspective. The houses and trees become smaller and the field boundaries move closer together as the land recedes.*

How do you paint skies and clouds?

The sky is the light source for the land and plays a central role in landscape painting. Even a composition that shows little or no sky will suggest the weather and time of day. A late evening sky produces completely different colours from an intense mid-afternoon light. Bright sunshine gives strong light-dark contrasts, but under a clouded sky there are no cast shadows to provide these and everything therefore looks flatter.

The sky is also important in compositional terms. The shapes of clouds can balance or echo those in the landscape, such as clumps of trees and link areas of the picture with repeating colours (*see pages 111, 137 and 199*).

The problem with clouds is that they move so fast, so it is useful to know a few basic rules. A high sun gives a harsh white light and you will see clouds with pure white tops, grey undersides and little variation of colour. A low evening sun casts a yellowish light, producing vivid yellows on the illuminated areas, brownish yellows in the middle and blues or violets below, where the clouds are in shadow. If the sun is below the clouds, the bottoms will be illuminated and the tops in shadow.

The patch of blue and the creamy white sides of the clouds, lit by the emerging sun, form a centre of interest in the sky area.

The lines and curves that radiate out from the patch of bright sunlight draw the eye in from the foreground to the buildings.

Above: Norfolk Landscape, *Alan Oliver. One of the most exciting effects of all is that of intermittent sunlight, with clouds casting shadows on the land below, or the sun suddenly emerging from a bank of clouds to spotlight some landscape feature. Here a beam of sunlight created a natural focal point, illuminating the house and far end of the field.*

How can I learn to paint realistic water?

There are two important points to remember when painting water. The first is that, even when broken by waves, it is a receding flat plane. This sounds obvious, but unless you observe the effects of linear and aerial perspective, you can make a lake or sea look like a vertical plane, or an inclined one, with the water seeming to run uphill. Waves or ripples toward the back of an expanse of water will be smaller than those in the foreground and the contrasts of colour and tone will be slighter.

The second point is that water is both transparent and reflective. You will always see some of the sky colour reflected in water and anything beneath the water can also influence its colour. A river running over peat may have a brown hue, with touches of blue on the tops of ripples. The sea may be greener or browner than a blue sky, because there is seaweed beneath the surface.

Still water presents a perfect mirror image of what is above. This is an attractive feature, but it can cause problems. Unless you introduce some visual clues to explain the water surface, the reflections will make no sense – they will simply look like an upside-down version of the landscape. You can blur the reflections in places, introduce small ripples or some floating leaves.

Disturbed water scatters reflections so that they are no longer the same height and width as the objects. Tone and colour vary more too, because each ripple consists of two roughly diagonal planes, one of which may reflect the sky and the other some landscape feature.

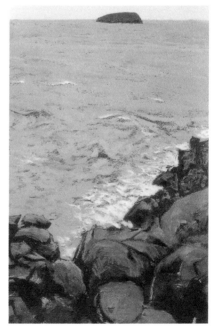

Above: Steep Holm, *David Cuthbert. The theme of this painting is contrast. The shifting quality of the water, which occupies the greater part of the picture space, is emphasised by the solidity of the foreground rocks. These play an additional role in providing a colour contrast; the warm browns, yellows and greenish browns set off the steely grey of the sea.*

Can you show me how to paint waves in a seascape?

Seascape is an enticing subject, but water is not always easy to paint, especially if you are working from a photograph. The advantage of the camera is that it can capture transient effects of light, but it freezes movement, making waves and ripples appear solid and static. If you copy this effect slavishly, your painting will fail to convey the essence of the subject. So use a photograph only as a starting point, as the artist has done here. By the use of lively brushwork, heightened colours and increased tonal contrasts, an exciting and vibrant picture was produced.

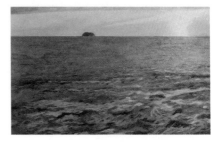

Above: Seascape, *David Cuthbert. This demonstration illustrates what an artist can do with a potentially dull subject. The artist used a layering technique with one colour showing through another to create a scintillating surface. In the sky, versions of each of the three primary colours (blue, pink-red, yellow) were laid one over another. The paint was thinned with water in the early stages and used more thickly as the work progressed. The working surface is heavy watercolour paper.*

1. The blue undercolour of the sky and deep purple-red of the sea were laid on with lightly watered paint. A mix of raw umber and ultramarine darkens the horizon.

2. A light magenta is painted over the blue in the central area of the sky, allowing the blue to show through slightly. The rock and dark band of cloud are both left as blue.

3. At the top of the sky, yellow is painted over the blue. The two colours mix optically, creating a greenish hue.

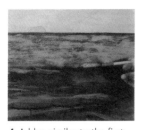

4. A blue similar to the first sky colour is brought in for the sea. The broken-colour effect, where the dark colour shows through the scumbled blue (*see page 112*), gives an excellent impression of light and movement.

5. Moving from one area to another so that all areas are at the same stage of completion, the stronger colours of the foreground sea are built up with decisive brushstrokes of blue over orange.

6. Next the final sky colour – yellow – is painted over the mauve created by the pink-blue mixture. The greenish-yellow cloud band is left as it is, because a darker colour is to be used for this.

7. The band of cloud is deepened and enriched with a strong orange applied over the yellow-green. Again, you can see how one colour shows through another to create a subtle mixture.

8. The effect of moving water is perfectly conveyed through varied brushmarks, with one colour laid over another. Toward the back of the sea, yellow was scumbled over blue to create a green glow.

9. Touches of rich deep mauve are introduced over the earlier blues. The yellow-orange brushmarks were made with the hairs of the brush slightly splayed in order to create a series of small fine lines.

I like cityscapes. Do you have any advice for painting buildings?

Although you cannot manipulate the lighting, you can choose the time of day that shows the buildings to best advantage. This is important, because the direction and intensity of the light affects the colours, forms and textures. When the sun is high in the sky, there will be fewest cast shadows and these play a vital role in highlighting interesting details and textures, as well as providing an interplay of lights and darks. A low evening sun, on the other hand, casts long slanting shadows, picking out features you might not otherwise notice. It also enriches the colours, turning drab brick walls into molten gold.

So take a look at your subject at various times of day and also in different weather conditions. If you want a brooding atmospheric effect – say, for an industrial townscape – an overcast day could be most suitable.

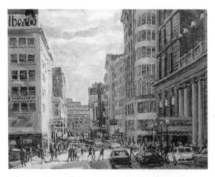

Above: Powell Street, *Benjamin Eisenstat. An attractive painting subject can sometimes be marred by the presence of cars and people, but they are an integral part of a daytime cityscape. Including vehicles, pedestrians and other city features can also help the composition. Here the yellow cabs are important to the colour scheme, balancing the yellows of the buildings and central patch of sunlight.*

Above: The Venetian Window, Chania, *Peter Folkes. You need not paint all of a building; separate details, such as windows and doors, often provide exciting possibilities. The artist contrasted the curves of the window with horizontals and verticals to make a balanced and satisfying composition in which lighting also plays a major role. The evening light casts a golden glow over the stonework to contrast with the blues of sea and sky.*

It seems accurate drawing is important in cityscapes. How can I be more accurate?

To paint buildings and urban scenes successfully you must understand linear perspective, our main means of creating the illusion of three dimensions on a two-dimensional surface. It is based on the observation that parallel lines on a receding plane, such as the bottom and top of a window, appear to converge.

If the parallel lines were to be extended they would meet at a point known as the vanishing point (VP). The location of this point is dictated by your viewpoint, because it lies on a notional line called the horizon, which is your own eye level. Thus if you are looking down at a town, the horizon will be higher than the buildings and the parallels will slope upward. If you are looking up at a tall building, the horizon will be low and the lines slope down.

Your angle of viewing does not alter the horizon, but it does affect the position of the VP on the horizon. Each plane has its own VP, so if you are looking straight at the corner of a house, there will be two and if several houses are set at different angles to one another, there will be more than one.

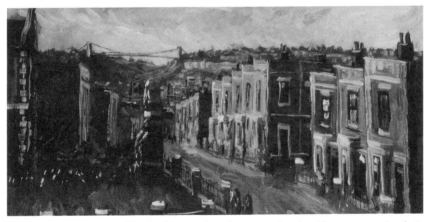

Above: South Street, *Gerald Cains. You need not be too precise about linear perspective, but unless you get the key perspective lines and angles right, the buildings will look structurally unsound. Although treated impressionistically, the structures in this picture are completely convincing, because the perspective effects are well observed.*

How do I arrange a beautiful and interesting still life?

In still life you do a lot of the composition before you begin to paint, so take time choosing and arranging the objects. The composition must be interesting and well-balanced and the objects must look as though they belong together.

Simple arrangements often work best. Move your objects around and be prepared to discard some items, or to replace them if the shapes and colours do not harmonise. Let some items overlap, because this makes a link between them, but take care that you can see both objects clearly. Do not crowd the elements together.

In all paintings, you want to lead the viewer's eyes into and around the picture, so try to set up signposting devices. The folds in a piece of drapery hanging over the table front will guide the gaze to the objects.

Check it through a viewfinder (*see page 166*). This will give you an idea of how the painting will look.

This group is overcrowded and fussy and the objects do not fit comfortably together.

The removal of many items and the introduction of the red pitcher makes a more pleasing arrangement, with a good colour balance.

The folds of the cloth provide a sense of movement and the colour sets off those of the objects.

An agreeably simple arrangement, with the curve of the table balancing the circles and ovals of bowls and eggs.

What advice do you have about painting interiors?

Painting domestic interiors is an extension of still life; you are dealing with inanimate objects, but on a larger scale. Another difference is that you cannot pre-organise the subject to the same extent, though you can, of course, shift tables and chairs and place objects to provide a focal point or touch of colour.

This subject is attractive because it is so readily available, but it is often overlooked by amateur painters. Many artists, past and present, have made lovely paintings of corners of their living rooms, bedrooms, or studios. Look around your home and try to see it with a painter's eye. A chair covered with scattered cushions by an open window, a mantelpiece cluttered with sentimental family objects; or morning sunlight streaming on to rumpled sheets may spark your imagination.

Light plays an important part in this branch of painting. A room comes to life on a bright day, with sunlight making patterns on the floor or walls. In the evening, when lamps are on, colours become richer and the atmosphere cosier. Sunlight effects are, of course, short-lived, so you may need to work in shifts at the same time each day. Artificial light will not change, but may not give you sufficient illumination. Overcome this by putting a separate light source beside your easel. Or make sketches and colour notes and construct the painting in the daytime.

Right: Armoire with Quilts, *Ron Bone. The artist made an exciting composition by slightly reorganising his subject; opening the closet door and placing a vase of flowers on the window seat. The door and the left-hand side of the bedding in the closet catch the light from the window so that the pattern of light and shade is continued into the centre of the picture.*

How can I paint successful portraits and figures?

The human form presents a complex interaction of shapes and forms and represents the ultimate challenge to the painter, demanding careful observation and a high standard of drawing. The best way to learn is to draw as often as possible. If you cannot join a life drawing or portrait class, draw your family and friends; take a sketchbook with you when you go out and make studies of people on buses, or sitting in cafes.

Most painting subjects require an underdrawing and for figure work it is essential unless you are very practiced. Begin with a light pencil drawing, erasing if necessary and do not paint until you are sure it is correct. When painting, stand back frequently from your work to see whether amendments are needed. If you are not sure, hold the picture up to a mirror. This makes it easier to pinpoint problems, because it presents you with a reversed and therefore less familiar image. The reflection also helps you to see whether or not the composition is balanced.

Above: The Yellow Rose of Texas, *Al Brouillette. When painting a standing figure, look for the way weight is distributed, as this affects the whole body. Here the model stands with most of her weight on one foot, so the hip that carries it is pushed upward.*

Above: Lunchtime at Café Rouge, *Debra Manifold. A painting where the figures are only one element is more demanding in terms of composition, but does not require a high standard of figure drawing. For it to work, however, the figures must look realistic.*

What are your best tips on portrait painting?

Achieving a recognisable likeness of a person is very satisfying, but this aspect of portraiture can equally well be carried out by the camera. For the artist, the likeness, although important, is only one concern. If the portrait is to succeed, you must give the same amount of attention to composition and colour as you would for any other subject.

Try to express something about the character and interests – and perhaps the occupation – of your sitter. Consider the question of clothes when you ask someone to pose for you. People look more like themselves in their habitual attire and someone you often see in casual clothes can appear unfamiliar when dressed up. If you are asked to paint someone, they will probably have their own ideas about clothing, however and the apparel might derive from the occasion such as a graduation or a wedding.

The setting depends upon the kind of portrait you intend to paint. There are three main types: a head and shoulders; a half-length, which includes the body down to the hands; and a full-length, showing the whole body, either seated or standing. The setting is unimportant for the first sort, because all you will see is an area of space around the sitter's head. You can adopt the same approach for half- or full-length portraits, leaving the background vaguely suggested, but you could use the opportunity to add some information by painting the sitter at home or at work, surrounded by personal objects.

And finally, carefully observe the proportions of your sitter's head. Head and face shapes vary, but there are some basic rules. The head's halfway point is the middle of the eyes. Ears are often made too small: they line up with the brow and the bottom of the nose. There is approximately one eye's width between each eye and, taking a line downward, the inner edge of the eye's pupil aligns with the corner of the mouth.

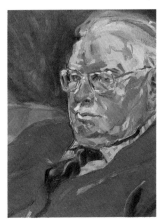

Above: Jean's Father, *Gerry Baptist. In this portrait on canvas board, the artist has used a traditional compositional arrangement, cropping the head on the right and thus allowing more space in the direction of the sitter's gaze.*

The perspective is slightly distorted, as it might be in a photograph, so that the side of the fireplace echoes the diagonal slope of the figure.

Above: Professor Eric Sunderland, *David Carpanini. When you paint friends or family, you can select the setting and the sitter's clothes, but for formal commissioned portraits the patron will usually do this. The artist's choices are thus more limited, but he or she still has control over the composition. This portrait is artfully planned, with the stark black and white of the figure framed by the middle tones of the room.*

The smile affects the entire face, not just the mouth.

The broad brushstrokes and lack of detail testify to the rapidity of execution.

Left: French Worker, *Sara Hayward. This artist enjoys making quick portrait studies of working people dressed in their everyday clothes and the painting is one of a series. The features are broadly treated, but the artist has expressed the jovial nature of the sitter by capturing what is obviously a characteristic facial expression.*

Is it okay to paint from my imagination?

Absolutely! Letting your imagination dictate how and what you paint can be very satisfying, but it can't be done to order. Indeed many people find it impossible. Children use their imaginations naturally, perhaps because their minds are less cluttered with seen images and direct experience than those of adults. Certainly the ability is often lost as they grow older.

There can be many sources for imaginative painting, dreams being one. Music and literature, especially poetry, can provide initial inspiration and so can memory, which – like dreams – often plays tricks with reality. It can be interesting to try to recreate a scene, perhaps a landscape or townscape, from memory, as you will often find you have

overlaid your impressions of shape, colour and so on, with more personal and subjective feelings, which will emerge in the painting.

Objects can form the starting point of an imaginative treatment, also. A strangely shaped tree, for example, might suggest a monster, while a favourite ornament or object with particular associations could spark off a fantasy with a visual storyline.

If you find it difficult to let your mind roam free, a change of media may help. Collage, for example, invites a non-liberal treatment and you could find that removing the restrictions of accurate representation enables you to develop a painting in a different way.

Left: Fluorescent Zebras, *Cheryl Osborne. A mixture of media has been used for this highly individual painting in which the artist has given free rein to her love of brilliant colours and decoration. Each of the zebra's stripes is painted in a different fluorescent acrylic colour; the sky is oil pastel, acrylic, coloured pencil and inks, while the grass is a mixture of pearlised inks, gouache paint and oil pastel.*

Glossary

Acrylics: A type of paint in which pigment is suspended in a synthetic resin. It is quick-drying, permanent and colourfast.

Aerial perspective: The effect the earth's atmosphere has on how people see objects as they recede into the distance. Objects typically become less clearly focused (softer edges) and appear to be more grey or blue in colour.

Archival (art materials): Having a neutral pH level that will allow the artwork to age well.

Binder: The adhesive that holds the powdered pigment together.

Blocking in: The initial stage of a painting when the main forms and composition are laid down in approximate areas of colour and tone.

Broken colour: A technique for applying paint in which the strokes of colour (typically varied) are laid down and left alone, not blended.

Composition: Arranging and combining different elements to make a picture.

Dry brush: A means of applying paint with a soft, feathery effect by working lightly over the surface with a brush merely dampened with colour. The hairs may be spread between finger and thumb.

Easel: Usually similar to a tripod, a base object that can be used to support a canvas while the artist is working or to display a finished artwork.

Ferrule: The metal band that encloses and holds the hairs or bristles in an artist's brush, thus attaching them to the handle.

Flat brushes: The type of artist's brush in which the hairs or bristles are all of equal length and the base (ferrule) is crimped so that the hairs or bristles lie flat, forming a rectangular shape.

Flow-formula acrylics: See soft-bodied acrylics.

Flow improver: A product that can be added to acrylic colour to make the paint easier to spread.

Focal point: The relatively small portion of an image made more interesting and engaging than the rest through the use of increased value contrast, brighter colours, greater detail, etc. Also known as the focal area or centre of interest.

Format: The shape of the canvas or surface, which can be a horizontal rectangle (landscape), a vertical rectangle (portrait), a square, or a circle or oval shape.

Full-bodied acrylics: See heavy-bodied acrylics.

Gesso: Acting as a primer, a type of base liquid, usually white, used to prepare the canvas or other surface for painting. Only acrylic-based gesso should be used with acrylic paint.

Glazing: Using a transparent film of colour over another pigment.

Gloss medium: Increases the translucency and gloss of acrylic colours while reducing consistency to produce thin, smooth paint layers which dry rapidly. This means that an unlimited number of glazes of exceptional brilliance, depth and clarity can be developed and exploited.

Ground: The surface preparation of a support on which a painting or drawing is executed. A tinted ground may be used to establish a medium tonal value on which to work or to establish an overall colour scheme to a painting.

Hatching: A shading technique that uses parallel lines instead of solid tone.

Heavy-bodied acrylics: As opposed to soft-bodied acrylics, these paints have a smooth, thick consistency ideal for laying down generous passages of paint, building up impasto applications and retaining the brushstrokes or visible signs of paint application.

Impasto: The thick application of paint or pastel to the picture surface in order to create texture.

Inorganic colours: See synthetic colours.

Linear perspective: The effect that distance and space have on the way people see objects as they recede into the distance. The farther away an object is, the smaller it typically appears to be.

Matte medium: A colourless paint-like substance that can be mixed with acrylic paint to make it more transparent and give it a dull finish when dry. Can also be used as an adhesive for collage.

Medium: In a general sense a medium is the type of material used, such as acrylic or charcoal. More specifically, a medium is a substance mixed with paint or pigment for a particular purpose or to obtain a certain effect.

Mixed media: The process of combining two or more media (such as acrylic and pastel) in a single artwork.

Modelling paste: See texture paste.

Moisture-retaining palette: See stay-wet palette.

Movement: In art, the manipulation of composition, design and subject matter to give the artwork a dynamic feeling.

Neutrals: When referring to paint colours, those colours that are not bright or intense but rather somewhat subdued or 'greyed down'. Usually achieved by mixing a bright colour from a tube

with black, an earth colour (such as sienna or umber), or the colour's complement (opposite on the colour wheel).

Opaque: The ability of a pigment to cover and obscure the surface or colour to which it is applied.

Optical blending: Mixing colour in the painting rather than on the palette, e.g. using dabs of red and yellow to give the illusion of orange.

Organic colours: Paint colours pigmented with natural, as opposed to man-made, substances, such as the cadmiums.

Palette: This term describes both the flat surface used by the artist to mix colours on and the range of colours selected by the artist for any given artwork.

Palette knife: A thin, flexible metal tool used to mix paint on the palette and/or to apply paint to the canvas or surface.

Pigments: The colouring substance in paints and other artists' materials. Some are organic while others are man-made.

Plein-air: The French term for the act of painting landscapes outdoors, from life.

Polymer resin: One of the key ingredients in acrylic paint.

Primary colours: In painting, these are red, blue and yellow.

Primer: A base coat applied to the canvas or surface to protect the surface and allow better, long-lasting adhesion of the painting medium.

Reservoir palette: See stay-wet palette.

Retarding medium: A transparent medium used to slow down the drying time of acrylic paints.

Round brushes: The type of artist's brush in which the base (ferrule) is round and the hairs or bristles have been selected and arranged within the ferrule so that they taper to a fine point.

Scumbling: The opposite of glazing. Working an opaque layer of paint over another of a different colour and allowing it to show through, giving a broken, uneven effect.

Secondary colours: The three colours produced from the combinations of any two primary colours: orange (red and yellow), green (yellow and blue) and purple (red and blue).

Sgraffito: In painting, a texture-making technique in which the artist scratches or wipes away some of the wet paint that has just been laid down to reveal some of the existing dry colour beneath.

Soft-bodied acrylics: As opposed to heavy-bodied acrylics, this type of acrylic paint is thinner and creamier, allowing it to spread and be thinned more easily.

Spattering: A method creating a mottled texture by drawing the thumb across the bristles of a stiff brush loaded with wet paint so paint droplets are flicked on to the surface.

Stay-wet palette: A special palette designed for use with acrylic paint containing a water reservoir that keeps the paint moist for several hours.

Synthetic colours: Any of the newer paint colours pigmented with man-made substances, such as the Quinacridone colours. These are often more intense and lightfast than their natural counterparts.

Texture paste: A very thick substance that can be mixed with acrylic paint, allowing it to be laid down in heavily textured applications.

Tonal values (tone): In painting and drawing, tone is the measure of light and dark as on a scale of gradations between black and white. Every colour has an inherent tone – for example, yellow is light while Prussian blue is dark – but a coloured object or surface is also modified by the light falling upon it and an assessment of the variation in tonal values is important to indicate the three-dimensional form of an object.

Transparent: The inherent quality of some paint colours to appear to be 'sheer,' allowing the colours beneath to show through. All acrylic colours can be made more transparent with the addition of either water or a medium, such as matte or gloss medium.

Underpainting: The preliminary, blocking-in of the basic colours, the structure of a painting and its tonal values.

Vanishing points: In linear perspective, all straight lines defining the edges of objects appear to recede into the distance toward these 'points' in space.

Varnish: A clear, transparent final coat applied to a finished artwork to protect the surface, which may be matte (dull) or glossy.

Viewfinder: An adjustable tool used to study a subject in order to determine the best format and composition for a painting.

Viewpoint: The position of the artist and thus the viewer, in relation to the subject as the painting was created. For example, if the artist stood on a high hill while painting the valley below, the painting would have a high viewpoint.

Index

Page numbers in **bold** refer to illustrations.